Unknown Territory
Photographs by Ray K. Metzker

Unknown Territory
Photographs by Ray K. Metzker

By Anne Wilkes Tucker
Notations by Ray K. Metzker

Aperture / The Museum of Fine Arts, Houston

The exhibition *Unknown Territory: Photographs by Ray K. Metzker* was organized by The Museum of Fine Arts, Houston.

Exhibition schedule:

The Museum of Fine Arts, Houston
November 17, 1984–January 29, 1985

San Francisco Museum of Modern Art
April 12–June 16, 1985

The Art Institute of Chicago
July 27–September 29, 1985

Philadelphia Museum of Art
October 19, 1985–January 5, 1986

The High Museum of Art, Atlanta
March 22–May 4, 1986

International Museum of Photography
The George Eastman House, Rochester, New York
June 6–August 10, 1986

National Museum of American Art
Smithsonian Institution, Washington, D.C.
September 12–November 23, 1986

Support for the exhibition and catalogue was received from the National Endowment for the Arts, Alice Pratt Brown, The McAshan Educational and Charitable Trust, The Jesse H. and Mary Gibbs Jones Exhibition Endowment Fund, Transco Energy Company, and Peat, Marwick, Mitchell & Co.

ISBN: 0-89381-154-8, cloth edition; 0-89090-033-7, catalogue edition.
Library of Congress Catalogue Card Number: 84-70443

Aperture publishes a periodical, books, and portfolios to communicate with serious photographers and creative people everywhere. A complete catalogue will be mailed upon request. Address: Millerton, New York 12546.

A list of publications from The Museum of Fine Arts, Houston is available upon request. Address: P.O. Box 6826, Houston, Texas 77265.

Cover photograph: *Composite: Philadelphia*, 1964
Collection of Philadelphia Museum of Art

Design: Massimo Vignelli
Type: G&S Typesetters, Inc., Austin, Texas
Separations and Printing: Beck Offset Color Co., Pennsauken, New Jersey
Bindery: Publishers Book Bindery, Long Island City, New York
Printed in the United States of America

Table of Contents

Essay by Anne Wilkes Tucker 6

Notations by Ray K. Metzker 14

Plates
Chicago 1957–1959 24
The Loop 1957–1958 24
Europe 1960–1961 38
Philadelphia 1962–1964 46
Double Frame 1964–1966 56
Composites 1964–1984 62
Couplets 1968–1969 72
Sand Creatures 1968–1977 80
New Mexico 1971–1972 90
Pictus Interruptus 1976–1980 100
City Whispers 1980–1983 108

Biography 120

Bibliography 131

Acknowledgments 142

Unknown Territory

Anne Wilkes Tucker

In twenty-five years, Ray Metzker has produced more than a dozen series of photographs, each series radically different from the others. He has steadily sought new vision, asking, "Why does new vision matter? Do I need this? Does it increase my capacity to care? No, but it increases my capacity to think."[1] For Metzker, the struggle for new vision is an act against inertia and stillness and toward intensity and knowledge.

Images whose meaning rests solely in the literalness of time and place do not interest him; he prefers to synthesize and transform, to create new, unknown territory for his audience to explore, and personally to escape what he regards as the banality and oppression of literal facts. His purpose is to probe, not inform; to originate, not crystallize. Metzker defines art as man's action on commonplace material. "To state something more than the material or the act," he says, "something must occur to make this object special. Just what that is and how it enters the work is always cause for wonder and endless speculation."[2]

The process of making art is as important to Metzker as the resulting photographs. The act of imposing his vision on banality gives him pleasure. He has no interest in photographs that convey economic, religious, political, or moral messages. When he talks about his work, he rarely assigns meanings to specific pictures except for occasional allusions made with titles. Instead, he refers to the general themes and influences of a whole series or talks about visual and technical phenonema. He views formal invention and humanistic concerns as the primary polarities between which his series alternate, although no series is exclusively about one polarity or the other.[3] Those which are more about human concerns are his most prolific series: *The Loop*, 1957–1958; *Europe*, 1960–1961; *Philadelphia*, 1962–1964; *Sand Creatures*, 1968–1977; and *City Whispers*, 1980–1983. For the viewer, these are the richest, most accessible, and most discomforting of his series, for they convey the extremes of hope and despair that imbue his work.

Between series that express Metzker's humanist concerns are series in which he extends photographic language through formal invention. He tenaciously investigates how something looks when it is photographed and how perceptions change when subjects are seen through a variety of photographic processes. He asks what we expect a photograph to look like and how those expectations affect its interpretation. He explores the evocative powers of abstract form and realistic detail. He tests the levels on which a work can function as an expressive statement.

Each new series of photographs begins with a change in his preoccupations about photography or with a change in what—or where—he is photographing. He opens himself to new experience and watches his ideas emerge and develop. He has said, "At that time I am scanning or simply looking. When I realize there are certain stimuli that I keep responding to, that reoccur in my perceptual field, then I can begin to identify a pattern." These new constants become what he calls his "terms," which are the contractual arrangements he makes with himself about an emerging series of pictures. The "terms" are both points of departure and the rules that discipline his work. They are both limiting and liberating, allowing him license to explore within their confines and to push until the terms are exhausted.

This working process evolved during Metzker's first major project, *My Camera and I in the Loop*, 1957–1958 (pages 24–37), which was his graduate thesis at the Institute of Design in Chicago. Metzker's initial "term" for *The Loop* was the physical boundary formed by Chicago's elevated railway, which encircles downtown. As Metzker photographed, he realized that the project was also about formal limitations: the relationship between his camera and himself, and his search for significant form, which took precedence over the objects yielding the forms. Using a Leica (with 35mm, 50mm, and 135mm lenses) and a Rolleiflex, he made images that explore motion blur, depth of field, vantage point, frame, focus, and back lighting, a sampling of the in-depth explorations that later work would encompass.

Initially inspired by the work of W. Eugene Smith, Metzker revealed in this series both wryness and sweetness in human events and gestures – observations of a cool, sophisticated eye. People are going about their business: selling papers, tending car lots, directing traffic, conversing. Metzker doesn't look for frailty, perversion, or defeat; he conveys the vitality of the city. The visual details that catch his attention range from the flutter of a petticoat and an arm holding a hat to sparkling white highlights that Metzker describes as "jewelie," from the word jewel. ("Jewelie" is the kind of sound / word Metzker frequently invents to convey his impressions; "jus, jus, jus" is another way of referring to points of dancing light.)

Beginning with *The Loop*, Metzker looked to street activity for what he calls "events." "I would see those relationships developing, and I would feel something fall into place," he says. "It wasn't that I came up to something and said, isn't that a nice arrangement? It was a sense of the tension, of knowing that these things were moving, and also that they had come into a position where the tensions were right and that was it. After a while it could happen simply with light."[4]

When Metzker traveled in Europe in 1960–1961, he mastered his skill of composing with highlights and heightened his sensitivity to lyric sweetness in human gestures. In his view, Europeans are unhurried; they converse, touch, and appear to integrate with their surroundings rather than pass through them in the preoccupied isolation that characterizes the people in the Chicago series. He also discovered what he terms "fluff," which is texture that delights him. He found it in flowers, dried weeds, rough woolen sweaters, and a clothesline of napkins. But there is dread as well as sweetness in the *Europe* series (pages 38–45). In *Almería, Spain*, 1961 (page 41), the "fluff" of a sheer black veil partially covers the horrific blind eyes of a crone; level with her eyes, her head is impaled by a streak of light. In *Portugal*, 1960 (page 43), the disembodied arm of a child floats in darkness toward a dangling rope.

Because Metzker was constantly on the move in Europe, with infrequent opportunities to set up a darkroom, there were long periods between making negatives and printing, a separation between conception and realization of the image that worked against formal invention. To establish and operate within clear terms while traveling was difficult. In every other series, Metzker stays in one place until the terms are set. "Familiarity," says Metzker, "breeds nuance."[5]

When Metzker moved to Philadelphia in 1962, the dual enchantment of photographing people and of composing with highlights was refined into two distinct pursuits. For the former, he concentrated on people watching parades. Some of the pictures were made at extremely close range, provoking wary stares from the subjects, a forced contact that is unique in Metzker's work. Others in the series, including *Philadelphia*, 1963 (page 53), are identified as "bittersweet family portraits, about 98 percent bitter." Still others are delicately balanced juxtapositions of pedestrians and grids of light, reminiscent of his Chicago pictures. Also like *The Loop* pictures, the *Philadelphia* photographs were taken in a proscribed area, within walking distance of Metzker's apartment.

At first, Metzker didn't like Philadelphia. For him, it had neither the vitality of Chicago nor the romance of Europe. Not wanting to describe his downtown neighborhood, he took graphic delight in its details: signage, wrought iron façades, street lamps, and pavement markings. In these widely published images from *Philadelphia*, people are either excluded or seen only in silhouette. The most striking aspect of these pictures is the economy of the compositions (page 8). They reach a simplicity and directness that Metzker regards as a climax in his pursuit of minimal but evocative spaces.

Beginning in the mid-1960s, with the series *Double Frame*, 1964–1966 (pages 56–61), Metzker's terms became primarily technical, chosen from photography's lexicon: the camera, focus, exposure, negative format, depth of field, optical perspective, the frame. Like his contemporaries in painting and sculpture, he began working through his medium's vocabulary, questioning established applications of technique. In the *Double Frame* series, he questioned the assumption that a photograph is made with only one negative. Using two consecutive negatives to make one picture, his term for the series dictated that the two frames had to be contiguous on the roll of film and the black line between negatives a constant element throughout the series. Having set his terms, he was free to explore the idea. The black line is always present, but not always visible, blending at times with dark shapes near the edge of each exposure. Merging shapes create spatial ambiguities and sometimes make it difficult to identify the subject. At times, Metzker further obscured what he photographed by shooting one frame as a horizontal and its mate as a vertical (page 60). The discontinuity is disturbing. The logic of Metzker's system is not immediately decipherable without seeing several of the photographs in the series, because as he continued to extend the idea, the variations overshadowed the single constant or term. What appears random is actually structured.

Other photographers have used sequential negatives to describe elongated subjects or to narrate stories, but Metzker's pictures are intentionally without narrative or descriptive motives.[6] In printing disjunctive images in a single frame, he addressed multiple rather than linear or "decisive" moments. This multiplicity reflects the incongruities of the city, where structures and manners are discordant and irregular. A rich dissonance results which Metzker acknowledges he prefers to the self-imposed, controlled order of the suburbs.

Metzker's subsequent series was large-scale photographic mosaics, titled *Composites*, 1964–1984 (pages 62–71). These are complex, systematically arranged collages. Ranging from 12×12 inches to 75×38 inches, their overall size adds to the initial shock of seeing them and accepting them as "photographs." In each composite, prints are assembled in rows, either of

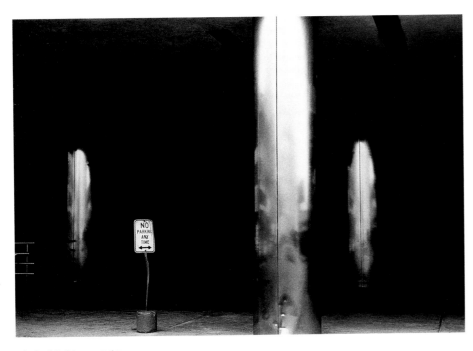

Philadelphia, 1963

single prints made from a limited number of negatives which are printed to different intensities or of long strips printed from one continuous roll of 35mm negatives.

Thinking of the entire roll of film as one negative is a self-imposed constraint. While working on whole-roll composites, Metzker requires subjects suitable for successive rather than single exposures; he reconsiders what is suitable to photograph according to this term. Generally he selects subjects with both architectonic and mobile components. He regards these terms as an opportunity "to deal with complexity of succession and simultaneity, of collected and related moments."[7] In some, he further complicates the image by overlapping images. By partially advancing the film in the camera, he creates non-linear motion and a multiplicity of perspectives. The exceptional complexity of these images is an extreme step from the graphic economy of the *Philadelphia* series.

In composites printed from one or two single negatives, the image is relatively free of layers and elaboration. The subject is singular (a sailor, an air conditioner, a window) but undergoes tonal changes each time it is repeated. In *Philadelphia*, 1964 (page 66), the same two sailors gain and lose texture and detail from frame to frame. The figures appear to alternately recede from the viewer in one print and advance on the viewer in the next. By altering the tones of his prints and by using an unpredictable overall pattern with a simple grid, Metzker created a rich confluence of information in a simple, direct design. The irregular placement of images in the composite affords random access to an intricate labyrinth without climactic points, lines, or moments.

In each composite, Metzker employs both abstraction and detail. He transforms the scene photographed yet retains certain factual details to anchor the image in its origins and ground his imagination. The elements of nature retained in the picture are part of the paradox of using photography to invent. In an exhibition titled *Deconstruction / Reconstruction: The Transformation of Photographic Information into Metaphor*, curator Shelley Rice recognized Metzker as one of the pioneers among photographers and painters who choose to work with information about the "real" world in order to "deconstruct" it from its normal visual contexts and "reconstruct" it into larger image systems.[8] Rice saw the coexistence in Metzker's work of philosophic and photographic concerns, and of evocative formal systems and descriptive detail. The overall design is simultaneously an artifact of his process and a metaphor for the complexity and discord he perceives in society. For example, in *Spruce Street Boogie*, 1966 / 1981 (page 69), Metzker visually transformed Spruce Street in Philadelphia according to the staccato sounds he associated with city streets. The wrought iron railings though which he photographed weave through the piece like spiraling musical scores. The normal threatening quality of a spiked iron fence is negated by how each fence merges into a longer diagonal and by the overall lightness of the tones and design. The sky and the street are blank white and have no weight or mass, a unique occurrence in Metzker's cityscapes. Pedestrians and passing cars are the most concrete visual data; they punctuate the design, creating tension between their specificity and the overall abstraction.

After *Composites*, Metzker returned to double-negative pictures in a series titled *Couplets*, although he no longer required that the negatives be contiguous on

the film. He freely combined two images from different times and places. A black line around the entire image became his unifying device for two otherwise discrete pictures. These paired images do not blend as in *Double Frame* and *Composites*, nor are they radically transformed. They are whimsical pictures, full of visual puns and analogies: ferris wheel and beach umbrella, boy on rocks and pigeon on sidewalk, girl at the beach and girl in the city. In *Atlantic City*, 1968 / 1969 (page 78), dichotomous images are paired: a woman in a black swim suit and a man in a white undershirt, her skin whitened by light and his blackened by shade. Sometimes, the connection is an implied, metaphoric relation as in Metzker's pairing in *Atlantic City / New York City*, 1968 (page 76) of the child and the man, both backlit, faceless and universal.

Metzker's terms are not always technical. They also evolve from his response to a specific place. The nature of his response to a location is in sharp contrast to that of artists who claim a subject through incisive description. Rather than include recognizable landmarks, Metzker accents those aspects that are usually considered backdrop but nevertheless are essential to what characterizes each place: the bleached, forbidding terrain of New Mexico, the infinite open sea air of Greece, the light-shafted, urban canyons of Philadelphia and Chicago. Therefore, the pictures from New Mexico are as unlike the ones from Philadelphia and Chicago as those pictures are unlike the ones made in Greece or on the beaches in Atlantic City.

Within a specific place, Metzker is also attracted by its ephemeral elements — pedestrians, clouds, shadows, bushes about to be trimmed, markings on walls soon to be repainted, highlights from a late afternoon sun. Of course, he doesn't always know that physical changes are about to occur, but he frequently finds a place completely changed when he returns to photograph.[9] He feels an affinity for and responds to the waste as well as the sensuality of decay and the mysteries in constant change. He loves the challenge of making an intense and vigorous image out of flux and impermanence.

Impermanence and flux are also expressed in his pictures as fragments: a face or arm disembodied in shadows, lights floating free of a building, a figure dissected by venetian blinds. Metzker acknowledges that fragmentation is a means of transforming an event to achieve a personal synthesis. "You have to break something down," he has said, "in order to have the parts to synthesize. If something's complete, there is no need to synthesize—it's complete, finished. In journalism, the photograph is of an event, whereas in my later work, the photograph *is* the event."[10]

When Metzker works in a new place for an extended period, his pictures are affected. He acknowledges that when he arrived in New Mexico in 1970, "the place was so different from anything I had experienced. The multiples didn't seem appropriate; the place was telling me something different. If you think of photographs as reflections or expressions of one's experience, then if your experiences are radically changed, the work's got to change." At that time, he returned to single-frame images, and as a term of the new work, he enlarged his print size to 11 × 14 inches. Also in response to the quality of light in New Mexico, his prints completely reverse all previous proportion of white to black. Whereas his photographs of cities are characterized by white highlights and solitary figures in deep black canyons, *New Mexico* (pages 90–99) is built of

dense black forms against white adobe walls and sky. The shadowy, bleeding, black voids and blinding white vacuums are softened only by what Metzker calls the "featheriness" of clouds, faded graffiti, and water from a sprinkler. These play amid the menace of the blacks and whites. The stark, forbidding mood of the pictures is strengthened by the threatening sharpness of normally innocent shapes, like palmetto leaves, pillars, and leafless twigs, and by the absence of people, except as shadows. Human presence is only intimated; the landscape is barren.

As a foil to the desolate loneliness of the New Mexican landscape, Metzker began to define the terms of a new series called *Sand Creatures* (pages 80–89). These pictures of people sprawled across the beaches at the New Jersey shore express his most intimate observations of humanity. The majority of the figures are reclining, asleep amid their possessions and entangled with their companions. Family units are endearing in the way they touch and echo one another's gestures. There is also a disturbing quality to the uncomfortable positions in which dreams run course through sleeping bodies. In some, sleep appears all too close to death; the sleepers have the open mouths of cadavers. But throughout the series, there is an ambience that these creatures are safe, relaxed, and unguarded. Metzker gathered what they presented: "delicate moments – unadorned and unglamorous, yet tender and exquisite."[11] Metzker's attitude, observed critic Kelly Wise, is "one of reserved and aware celebration."[12]

After Metzker returned from New Mexico, he experienced a particularly fecund period of working and evolved new series by alternating periods of term-directed work with free experimentation in the studio. These studio works are his most formalistic, least illusionistic pictures. He identifies the experimental periods as "trying to rake up the soil again. It is knowing when to speak and when to listen, when to follow and when to control the work. The studio is a world apart from the street. Both have a different beat. The street demands selection and the studio, construction, physical manipulation." In the studio, Metzker lets ideas tumble and processes blend, evolve, and give birth in turn to new ideas and processes. While the studio has been the source of ideas that produced remarkable and widely published pictures, it has seldom given rise to a full series. In fact, only two fully developed studio series have emerged: *Whimsies* (page 10) and *Wispies*, both begun in New Mexico and completed in the early seventies.

There are also ideas that Metzker carries from the studio to the street. The studio work of the mid-1970s culminated with the series *Pictus Interruptus*, 1976–1980 (pages 100–107). For *Pictus*, he fashioned objects in the studio to be included in photographs made outside. He held small objects directly in front of the camera lens, partially obscuring the scene beyond the object. Extending the predominance of light over dark tones which began in *New Mexico*, the images of *Pictus* are composed of angular black occluding devices held against hard white planes or of winding white shapes on light gray fields. Much of their beauty rests in their tonality, an elegant grayness first achieved in his studio in the short series *Philadelphia Flashed*, 1975.

The *Pictus* photographs are breathtaking in their originality and disjunctive associations. They are haunting and indecipherable. The viewer receives opposing signals about what is important. Traditionally, the most important

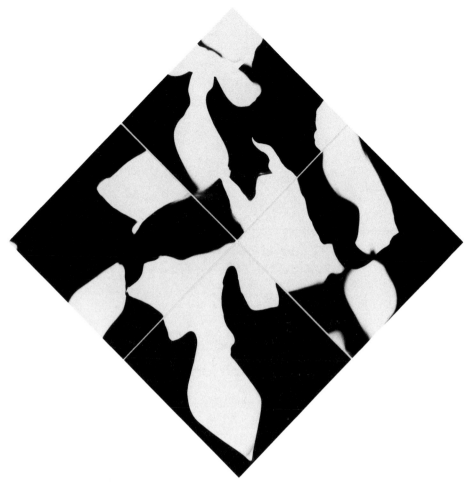

Whimsy, No. 4, 1974

objects in a picture are in focus and centrally located in the foreground, but in *Pictus* the foreground is out of focus and partially obscures the sharply focused landscape beyond the interrupter. The foreground becomes a barrier, blocking and teasing the viewer about the view beyond.

The *Pictus* series began during Metzker's self-appointed sabbatical in Greece in 1976, and upon returning to America, he retained the spatial openness of those Greek seascapes. For the first time in his career, he began to photograph the city from his roof, where the horizon was visible, rather than work in the dark, closed canyons of the streets. He also began to photograph in the soft light of dusk rather than in the harsh extremes of full, late-afternoon sun. In *Pictus Interruptus: Philadelphia*, 1980 (page 101), he transformed a dried leaf into a silky gray ornamentation floating over a city whose towers are backlit and barely perceivable in the twilight. As in *Double Frame*, people in *Pictus* are only signified by their artifacts, but the occluding forms are animated, occasionally anthropomorphic.

In Metzker's most recent series, *City Whispers* (pages 108–118), people are isolated, fragmented, and often faceless. While his cities are neither inviting nor kind, the streets are jumpy with bright lights and movement in a lively play of highlights, shadows, and reflections that contradicts the weight of human isolation, of beings alone in a huge dark universe. The bittersweet pain in the pictures is made palpable through the elegance of its expression.

This recent work incorporates ideas and pictorial devices from previous series without establishing elaborate, technical terms. He achieves, in single-negative format, graphic events first realized in multiple-negative compositions. The spatial ambiguities created by abutting two negatives in *Double Frame* are brought about now with shadows and shafts of light. The fragmentation achieved by overlapping negatives in *Composites* is accomplished in *City Whispers* by photographing naturally overlapping shapes (page 12). As in all of his previous work, the "event" that he is photographing is light, but in *City Whispers*, he reaches new levels of synthesis and control of multilayered scenes. His metaphors are now handled with the assurance of a mature artist.

Metzker the man is quiet, intense, with an impishness and wit that belie the rage and tumult within. He is courteous but uncomfortable with small talk and slow to warm to strangers. As he says, "I am aloof, but I always have an antenna out for the serious person."

Although some people are energized by social intercourse, Metzker is of the school that counts people as either one, two, or many. He lives alone and owns neither a television nor a car. He reads constantly from neat, ever-present stacks of books and scholarly magazines. The subjects range widely but rarely include goal-directed, activist disciplines with projectable ends – no politics, science, or medicine. What he chooses is more contemplative: poetry, philosophy, aesthetics, culture, logic. While in New Mexico, for example, he read works by William Blake, Hermann Hesse, Nikolaevich Tolstoy, Gabriel García Marquez, John Dewey, Jacques Lacan, George Whalley, Gabriel Marcel, and Henri Poincare on subjects ranging from Existentialism to Structuralism

to Russian Constructivism to poetry. He prefers classical music; his house is frequently filled with the music of Shastakovitch, Ives, Mozart, Poulenc, Ginastera, Penderecki, and Albinoni.

In his journals and through interaction with friends, Metzker questions what he reads and its relevance to his work. Discussions take place over leisurely meals. Metzker is an inventive cook with a keen sense for odd but appetizing combinations of ingredients and a whimsical eye for color combinations on the plate. But even with his closest friends, Metzker is protective of his time, insisting that, if he is to accomplish anything, control of his daily life is as important as control in his pictures.

The purposeful craftsmanship in the old firehouse he bought in 1966 and remodeled as his home and studio mirrors the craftsmanship in his art. In house design, as in teaching and art, he questions everything. Decisions as routine as the placement of light switches receive reflection to ensure both practicality and flair. Unlike his photographs, which adamantly remain black and white, the house facade is polychrome, with selected interior walls and carpets of bright hues of blue, magenta, and green. He was attracted to this building that was halfway to oblivion when he bought it. Restoring the facade was part of retrieving it from anonymity.

Born into a traditionally conservative midwestern home, Metzker learned the protestant work ethic from his parents' example. His father had an accounting business and encouraged Ray to become a businessman. Being a child of the Depression, said Metzker, meant "life was at home; it was a reasonably somber period." Adding to economic and cultural sobriety was the fact that Metzker's older sister was an invalid because of cerebral palsy and that his parents chose to care for her at home, a situation that had a profound and complicated impact on him. On the positive side was the hope and strength conveyed by his parents in caring for her. But the experience of her illness forced on him the notion of waste and fueled his creative drive. As an adolescent, photography "was the ladder out."

There have been subsequent times in Metzker's life when he's been driven by negativity. For example, the army was a negative experience. What he viewed as the army's mindless moving of men to no clear purpose made him eager to leave the military and impressed on him his need for more education. He took an early discharge to begin graduate work. Some aspects of teaching were also disheartening because of administrative emphasis on issues Metzker considered peripheral. Martus Granirer, Metzker's colleague at Philadelphia College of Art in the mid-1960s, remembers sharing Metzker's frustration: "I recall long discussions of what was needless and constraining in the training given to our students, and what would, we hoped, bring out their potential. It seems that Ray and I, each in our own way, believed that there was more to be learned by the faculty from school than we could extract in the restricted teaching climate we then found around us."[13] Although he enjoyed his dialogue with students, the results of teaching remained far from Metzker's ideals. As his own work became focused, the dissipation of energy through teaching was difficult to reconcile. This drain led him to apply for grants from the Guggenheim Foundation and

from the National Endowment for the Arts and once to fund his own sabbatical. In 1983, he stopped teaching, forgoing financial security for more energy and time to photograph.

The historical context for Metzker's photographs begins in the 1920s with the Modernist movement in America and Europe. In America, the Modernists were led by Alfred Stieglitz, Paul Strand, and Edward Weston. The primary component of their aesthetic was a shared belief that photographic tools should be used to do what they could do uniquely better than the tools of any other medium, which was to produce "pure" or "straight" photographs with a wealth of detail and accentuated tonal contrasts in infinitely subtle gradations. "Straight" photographs were visual records direct to the point of illusion, accomplished without what were regarded as trick or manipulative photographic processes.

The second component in the photographic aesthetic of American Modernism was photography's potential to educe personal expressions from abstract form. Stieglitz, Strand, and Weston each accepted metaphor as a means for personal expression and abstraction as a means to achieve pictorial power, so long as abstraction did not negate the record of detail and tone. The final component in their aesthetic was the image of the artist as Prometheus, creating alone through great struggle.

The European László Moholy-Nagy was a contemporary of Strand and Weston. He also regarded photography as a tool with unique inherent qualities and shared their conviction that the nature of the medium must determine its aesthetic. But rather than try to codify what was inherently photographic, Moholy's interest was solely in extending photography's boundaries in order to extend man's vision. For Moholy, "the enemy of photography is the convention, the fixed rules of the 'how-to-do.' The salvation of photography comes from the experiment. The experimenter has no preconceived idea about photography.... He dares to call 'photography' all the results which can be achieved with photographic means with camera or without...."[14] Moholy also regarded photographs as objective, mechanical records that could be used to extend man's vision but not as vehicles for personal expression.

From 1922 to 1928, Moholy-Nagy was an instructor at the Bauhaus in Weimar, and later in Dessau, Germany. At the Bauhaus, photography existed as one of a number of technologies for use in a student's training but was not a subject in the curriculum. In 1937, when Moholy became the founding director of The New Bauhaus in Chicago, he brought with him the Bauhaus legacy of envisioning a world made beautiful by art and design and a society made better through the works of the architects, designers, and craftsmen educated by the Bauhaus method. The core of Moholy's educational system was a solid exposure to multiple crafts (every student took painting, sculpture, design, and photography) and a foundation course for each craft that thoroughly pressed the student to experiment and to seek a "new vision."[15]

In 1946, shortly before his death, Moholy hired Harry Callahan to teach photography at The New Bauhaus, which had been renamed the Institute of Design (ID). Seven years later, Callahan hired Aaron Siskind. Callahan and

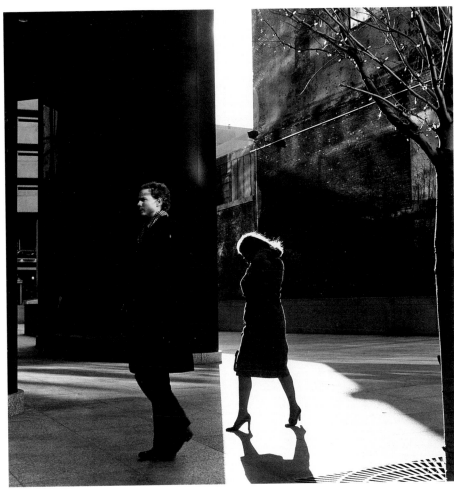

City Whispers: Philadelphia, 1983

Siskind retained the foundation course for both undergraduate and graduate students, but de-emphasized the experimental techniques as ends in themselves and "injected the idea that subjectivity underlies the camera's graphic objectivity."[16] As Siskind and Callahan explained the program in 1956, "The general direction of the training is from the abstract, the impersonal, the exploratory to the personally expressive. And our aim can be stated: from within the framework of a broad professional education to open an individual way."[17] The ID grafted subjective expression from the American modernist tradition onto European experimentalism.

In 1956, Metzker enrolled at the Institute of Design to earn a master's degree in photography. The program was critical to his development. Without awareness of its source, Metzker drew on Moholy's mandate to experiment. He responded immediately to the school's emphasis on activity and investigation over "right" answers. The ID's hands-on practice with other arts continues to imbue his work with an uncommon awareness of the work of his contemporaries in other fields. From Siskind and Callahan, Metzker drew foremost on their examples as working photographers whose entire lives were based on commitment, intelligence, and hard work. He recognized that "as artists, they merge mind, hand, and heart." Through their example and their teaching, he gained confirmation of photography's validity as a means of personal expression.

Metzker has pursued, with more vigor than most, a relentless, formal, problem-solving approach to photography which characterizes the work of most ID graduates. Metzker also shares with other Callahan and Siskind students a search for significant form which takes precedence over the objects yielding the forms. Finally, he shares what critic Andy Grundberg called the common superficial features in the works of ID graduates: "a stark black-and-white field, deep printing, an emphasis on high-lit contours, the tendency to see in terms of planes of light and shadow, plus a designy quality."[18]

The critical responses to Metzker's work have been affected by the slow acceptance in America of Moholy's ideas and of their modification and extension by Siskind and Callahan. Initially, critics were hostile to the practice of abstraction in photography. They did not look beyond formal invention for meaning and recognized compelling graphic impact as the sole attraction of Metzker's work. But even sympathetic viewers have been hampered by the lack of a published overview of his work. The scope and sequence of his series have not been available, especially compared to the accessibility of work by such of his contemporaries as Lee Friedlander, Garry Winogrand, Duane Michals, Paul Caponigro, and Robert Heinecken. As Peter Bunnell recently observed, Metzker has remained "somewhat outside the customary gallery / publication interlace."[19]

Why is this so? One reason is that Metzker has been obsessed with his work and has spent little effort embellishing his reputation. Nor have the complex patterns in his work been clear before, in part because his strongest images have been published singly or mixed in exhibitions with works from other series. And he has not been very helpful: there has been little explanation, clarification, or looking back. Instead, he is intent on achieving new vision. Like an alert, wondering child, his mind is constantly supposing: "What if?" Ray Metzker's restless experimentation will continue to find terra incognita the most promising words written on the maps of human knowledge.

[1] All unattributed quotations by Ray K. Metzker were made to Anne Tucker and recorded in her journals in 1983 or 1984.

[2] Metzker, loose notes in folders, 1978–1979.

[3] Metzker is drawn to polarity and manifests his interest both by setting up polarities in a single series (hope and despair, simplicity and complexity, terror and sweetness, menace and play) and by alternating in successive bodies of work (human concern and formal invention, studio fabrications and unmanipulated negatives).

[4] Chuck Isaacs, "Ray K. Metzker: An Interview," *Afterimage*, vol. 6, no. 4 (November 1978), p. 15.

[5] Metzker, loose notes in folders, 1977.

[6] Metzker acknowledges, however, the influence of Arthur Sinsabaugh's elongated-frame, midwestern landscapes.

[7] Statement to Guggenheim Foundation, 1966.

[8] New York: The New Museum, 1980, p. 8.

[9] There was a joke in graduate school that for Metzker to photograph a building meant it would soon be torn down.

[10] Isaacs, ibid, p. 17.

[11] Ray K. Metzker, *Sand Creatures* (Millerton, New York: Aperture, 1979).

[12] "Sand Creatures," *New England Journal of Photography*, vol. 1, no. 3 (June 1980), p. 14.

[13] Letter to Anne Tucker, April 9, 1984.

[14] *Vision in Motion*, quoted in Lee D. Witkin and Barbara London, *The Photograph Collector's Guide* (Boston: New York Graphic Society, 1979), p. 195.

[15] For history of The New Bauhaus / Institute of Design, see "The New Vision: Forty Years of Photography at the Institute of Design," *Aperture*, no. 87 (1981). See also Abigail Solomon-Godeau, "The Armed Vision Disarmed: Radical Formalism from Weapon to Style," *Afterimage* (January 1983), pp. 9–14, and Rosalind Krauss, "Jump Over the Bauhaus," *October*, no. 15 (Winter 1980).

[16] Andy Grundberg, "Photography: Chicago, Moholy and After." *Art in America*, vol. 64, no. 37 (September 1976), p. 36.

[17] Aaron Siskind and Harry Callahan, "Learning Photography at the Institute of Design," *Aperture*, vol. 4, no. 4 (1956), p. 147.

[18] Grundberg, op. cit., pp. 34–39.

[19] "Ray Metzker," *The Print Collector's Newsletter*, vol. 9, no. 6 (January/February 1979), p. 177.

Notations

Ray K. Metzker

Numbers appearing in parentheses after each quote refer to sources as follows: (1) letter to Anne Tucker, (2) Ray K. Metzker journal, (3) Anne Tucker journal, entries from conversations with Metzker in 1983 unless otherwise noted, (4) letters to third parties, (5) Metzker, loose notes in folders. These passages have been edited for this publication.

People are seen today as wandering (if not lost) solitary figures subject to a labyrinth of fantasies, laboring under the imaginary quest for utopian freedom, afraid of their singularity (individualness), dependent on the now and apprehensive of the future, stripped of charity, lamenting war but unable to live in peace.

We look for the model, the paradigm, but find only the flawed, the different, the irreconcilable, the unresolved. Where all must be accounted for, silence and voids are unsettling nightmares, disquieting annoyances. *(5; 1977–1978)*

I recognize the desire, the need to affirm. This requires reverence and a belief that there is purpose and meaning to our being. To make work and life meaningful is a struggle. Were we not to try, life would be sad and empty. From the magnitude and intensity of the struggle comes the greatness we hope for. *(2; undated)*

You stand out there with nothing on, with so much at risk. It is amazing that one proceeds, but one does. Chance is essential, so related to genuine discovery and the affirmative process.

Art must affirm. This is our treasure: our capacity to affirm human intelligence, sensibility, inventiveness. Art is not a luxury; it is the clue for man's hope. *(3; 1984)*

I approach photography in the context of art, as a key to understanding. It is my connection to the world and it functions in two ways: it lets me fly and it grounds me. There are indeed pleasures to working, but it is more of a struggle for purpose.

Who doesn't first approach art with the dream of becoming famous enough to have one's work win a national prize, or hang in a major museum, or appear in a major publication? Powerful as that dream is, it is not too long before something called the truth appears. That makes the going slower, more challenging. Vain claims to greatness are tempered by unsettling questions related to truth-seeking. It becomes necessary to acknowledge the importance of honesty and forthrightness. *(2; 1980)*

Somewhere in development the artist comes to a juncture, with one path emphasizing self-importance and the other leading to passionate concern for ideas. To follow the latter path calls for a divestiture of self, an effacement, a drawing away from egocentricity. One marvels at the thrill of participating, one experiences awe and wonderment at the mystery of seeing the diverse come alive to reveal meanings. *(5; 1977–1978)*

Art is man's action on commonplace material. To state something more than the material or the act, something must occur to make the object special. Just what that is and how it enters the work is always cause for wonder and endless speculation. Strong work startles us. We recognize the ingredients, but we can

hardly believe the result. Something jumps, glows, flutters. It has tactility, flavor – so convincingly we say it is real. *(5; 1978–1979)*

Photography provides the means for speculation about meaning; I am not an objective reporter. I prefer to go further, to the unstated things of our existence. What I can't understand and grasp seems to lead me. Speculation is part of all art. *(3)*

As a creature in this world, I have to reach out and touch. That is a very deep motivation; to interact, to touch, to examine as a means of survival. Photography can take me out of the ordinary world.

Once I start touching, I start shifting. I begin to push, trying to transform meanings. Manipulation leads to discoveries. That which we retain is what we call our reality. That's what appears in the pictures. *(3)*

It is not a question of what one chooses to do, but how one does it; not whether it is intellectual or emotional, but whether it is inventive, enriching, or caring. Does it touch central issues or play on peripheral issues? *(2; 1980)*

The artist does not need to follow an event. Instead, he takes what is workable in his system of values and determines his own event, injecting and incorporating visual devices (confusing the space, eliminating detail, introducing ambiguity). The artist looks on objects and sensations as providing the raw material and imposes a scheme upon it. *(5; 1977)*

Isn't art the need to hold, to make visible, what we believe or wish to believe? The elusive search, the frustration of incompleteness or inadequacy, the failed attempt at seeing, catching, recognizing, knowing something that points to and reveals the nature or essence of our being – this attempt is an act by the artist: art is the message of that act. *(5; c. 1977)*

Rage is about the world not being what it could be. The euphemism for this is passion. It is often triggered by disappointment or dissatisfaction. In the artist, it has to be more than anger; it has to be rage. The fire has to burn strong. What saves the artist is that working caps the rage and channels it into something constructive.

If you have any intelligence, you realize that rage will destroy you, so you have to discover sweetness, to seek balance. Some things I point to but know not to dwell on them, for to dwell would be to sink and invite the viewer down. That is no solution and shows no sense of invention. Menacing and yet playful. I am always conscious of those features. *(3)*

The key term is waste. Wasted time, wasted material, wasted effort, wasted people. Think of the waste attached to wars. Nothing depresses me more than human effort which results in nothing. Each day the media scream that this-and-that is important, when this-and-that doesn't add up to anything but incessant noise. I want to go in the other direction. Substance is my obsession. *(3)*

My sister was a lifelong invalid, which had a profound impact on me. It was a difficult situation for anybody to surmount. Clouded with fear and despair, the problem had no solution. It was not the battle of life, but the wait of an unending night. *(5; 1962–1963)*

To be with someone denied the normal experience of life impressed the notion of waste upon me. In an intuitive way, I recognized it early. On the positive side, caring for my sister was a hopeful act by my parents. Their life was not easy, but there was strength in the way they responded: *(3)* Whatever their sorrow and suffering, which was by no means inconsequential, they chose to bear it in silence. *(2; 1979)*

Silence has a role of ascending importance as a mode of communication. Without it, we cannot really hear the subject that needs attention. Noise prevents dealing with either past or failure. Noise is an auditory drug. Chatter, babble, disco, rock fill the air with the pretense of something but say nothing. *(2; 1979)*

The explanation of why we work is not simple. Some say: "I like beautiful things" or "I want to express myself." *(5; 1980)*

I know this about myself: I have to lay hands on, to seize and to build, to beat the stuff until it resonates. *(5; 1980)*

I doubt if any work can really be called fun. Fun is just that: carefree and irresponsible, a light moment, a respite from our endeavor. However, there is joy, full of body, which one encounters only from intense endeavor. *(5; 1962)*

The need to make photographic images now goes so deep that it is difficult to imagine doing anything else. Photography serves as the alter-ego, the "other" of my private dialogue. There is something in that light-formed, silver-fixed image that causes me to respond with excitement. *(4; 29 November 1970)*

Photographic life alternates between periods of reflection and work. The questioning that goes on during reflection is – as it should be – unsettling. Working is the attempt to step off into space. The heat of intensity melts the bands of restraint. *(5; fall 1983)*

Most significant work is the result of concentration, which implies a shedding of the non-essential. In the end, the mix of what remains gives character and meaning to the work.

There are a number of strong examples to look at: Aaron Siskind's rocks and divers, Bill Brandt's nudes, Richard Misrach's cactuses, Arthur Sinsabaugh's elongated landscapes, Marsha Burns' and Robert Mapplethorpe's portraits. In each of these artists' series, look for the constants. Often you will see that they are obvious and simple. Then look for the way these constants have been worked, combined, added, and subtracted. Finally, consider the different meanings that result. Along the way we discover how some small decision, a different attitude, maybe even an intrusion, adds a whole new dimension.

The more you are willing to invest in your work, the greater the clarity you will get in return. *(4; letter to student, 25 May 1982)*

What is alive is in the midst of becoming. Acts in the light of meaning can be construed only as tentative. Action is of the now; meaning exists in past action. The act anticipates future. *(2; Greece, 1979)*

To live is to project. Our lives are balanced to the future; today is the preparation for tomorrow. Experience constantly instructs that the next will be better than the last – unless, of course, one is committed to nostalgia. *(2; Greece, 1979)*

Because daily living requires being positive, the tentativeness you have to maintain in working is formidable. For the sake of sanity we need certainty. To a great extent we fabricate and manipulate our lives to create new illusions of certainty. But working takes us into an area where we face uncertainty. Sometimes it's very frightening. Either courage or obsession bring us through. The toughest thing is to know when to be decisive and controlling and when to roll with the work and let it take over. When do you force and when are you receptive? *(3)*

Often as I am working, the developments inform me, and that influences the next step. Sometimes I want the work to do one thing, but it proves unwilling and tells me to do something else. *(5; 1978)*

Without transformation, work would be a dull activity. Being cognizant of transformation, one senses the mystery and the joy of existence. All of our world has potential as material for our remaking. Excitement comes with seeing something in a new meaning that we previously either took for granted or overlooked. *(2; fall 1977)*

Imagination delights in leaps; change is cherished. Changing something into something else...something happens.... We detect a spirit, elusive and fluttering, beyond the pale of knowing.

The elusive is what we seek, be it of the heart or the mind. The artist learns to live with uncertainty, for it is in meeting the unknown that spirit is exposed and tested. The certainty of knowing is fool's gold. *(2; fall 1977)*

The artist digs holes to trip the viewer; climbing out is the act of participation. Slick work does not have the means to hold the viewer. *(5; 1977)*

Design is overemphasized by others as a deliberate concern of mine. One could justly speculate on the influence of the Institute of Design and its concern for form as well as the influences of both Aaron Siskind and Harry Callahan, two photographers sensitive and obligated to a rich visual language.

For me, design is more innate, operating subconsciously or automatically. If anything, I have tried to restrain it. I was particularly aware of this in the *Sand Creatures* series.

Design is part of the total package. It is the vehicle for the idea, which is the attempt to integrate experience. The design elements can serve as signals to attract and direct the viewer and to suggest something. They can create an effect at a distance or at first viewing, but there has to be something else as the viewer comes closer to the work. *(4; 20 November 1970)*

I experiment with forms and probe for experience. Form cannot live without experience nor can experience communicate without form. There is the magic of forms and the mystery of our lives. Where they come together is where I have a photograph that is vital. *(1; July 20, 1983)*

Formalism implies gamesmanship – how you move from A to B, how you capture the queen; it is separate from and only a container for the encoded life experience. What is contained is not always obvious – but that's part of the gamble. *(4; 1984)*

Ultimately, the concern has to be for images with symbolic content. Frequently, encoded experience is the stuff for speculation. That images can affect us we cannot deny, but how and why? *(5; lecture at The Art Institute of Chicago, undated)*

Eventually, one has to meet the notion of responsibility, which is the point of all meaningful work. It is not enough, not fulfilling, to live the now as an isolated moment for the pleasure of self. Meaning grows when one begins to think of the future and the welfare of the collective. *(2; 1980)*

The order of my working process: observation, questions, seeing the problem, concentration, obsessive examination. *(1; Greece, 1979)*

The first part of the process is open-ended, when I am scanning or simply looking until constants, or terms, emerge. When I realize there are certain stimuli that I keep responding to, that reoccur in my perceptual field, then I can begin to identify a pattern. What is really curious is how the clues appear in other areas such as what I am reading or discussing or noticing on the street.

The second part of the process then begins: structuring. I start to rid myself of other elements, close the door around what I have. Then I begin to beat through to the inventive process, where playfulness becomes important. Invention and play work together. There is a new-found freedom to play. When it is finally time to invent, I am soaring. By then I know my terms. *(3; 1984)*

I often talk about "terms." These are the contractual arrangements I make with myself about an emerging series of pictures. After I discover what my terms are, there is a rush of work, and I will push until the terms appear to be exhausted. *(3)*

The terms form the armature on which I hang the things I find; new terms are different from those left behind. At one time terms might have been about technical matters: double frames, print size, grain quality. Today my terms have much less to do with these photographic characteristics than with impressions. In *City Whispers* I want a deep space that overpowers the figure: worlds of voids. *(3)*

When I work, no moment stands out as of any greater importance than any other moment. With each frame there is hope, but at no time while I am photographing can I assume that I am succeeding. Sometimes I think I know. I have a sense of something germinating, of some threads. I am glowing. Of course, experience has taught me that what one sees in the darkroom often doesn't match the expectation of the initial encounter. Still, it is amazing when out of a day's work an image has resulted that can affect somebody. *(3)*

From the breakfast table, I catch sight of two figures silhouetted against the sky, visually mixing with the silhouette of plants hanging at the window. Since my customary view is of static lines, the appearance of man-shapes is a surprise, and I reach for my camera. Chance meetings are the intrinsic subjects of photographs. *(2; 1980)*

Previsualization can lead to constipation very quickly. Previsualization and the large format go together. Being so sure before you click the shutter leads to a rigid result. Without previsualization – and given a little space and time – a sixth sense will discern what is happening. The photographer has to reach and grab it. *(3)*

A photograph seems to come to us on the wings of angels. It harks of magic. The uninitiated assert that photographs appear without antecedents; background and preparation, which are the feat of serious work, are overlooked. *(2; 1976–1977)*

We hear a good deal about intention. Many artists and viewers are inclined to attribute to the artist powers of mastery which may exceed the fact. One of the fictions commonly cherished about photography is that images are made in a flash, a significant or great picture delivered with lightning speed. I like to refer to this as the Immaculate Conception Theory. *(5; 1978)*

It's easy to get lost if an aesthetic goes no further than technique or composition. It is something else to examine the work for the maker's concerns or values to see how personal sensibilities are manifested. The self needs to be tested and new doors opened on the way to discovering the terms of personal aesthetic. *(2; 1976–1977)*

Many of those working in the medium are not taking the photograph beyond some kind of factual notation. Often, accompanying verbal description is far more exhaustive and animated than the photograph, which is an unconvincing visual experience. This kind of picture operates as a sign.

Signs are important for what they point to and have value when the community understands their use. We ask that they be readable, in order, and above all functional with more than a modicum of accuracy.

Art has other concerns. It must fight its way above the flood of overwhelming detail. It strives for larger meanings. It would peel away the husk from the seed. It is an embodiment of essences. *(5; 1978–1979)*

Time and again I reject the lifelessness that I find in so many photographs. It is mere exercise to execute theories and follow prescribed methods, working each detail to the maximum, only to end up with a dead body. That the work will ultimately have a life of its own is the undeniable challenge of working. *(5; fall 1983)*

Excitement is to be found in the suggested, in what the minimum of articulation can lead us to see. It is one thing to enhance the obvious; it is quite another to catch the elusive. We pluck a few threads from reality and weave them into another reality, perhaps producing a package of wonder, formed of light and silver, with poetic and mystical charms. *(5; 1977)*

The photograph is appreciated and most often exploited in the commercial application for its recording of detail, the ability to absorb minutiae in a fraction of a second. One of the tasks of art is to control this information. *(5; 1977)*

Unnecessary detail is the death of a lot of photographs. The viewer can see and

get involved with every pebble, but the experience is only inventory-taking. No work is left for the imagination. *(3)*

We are experiencing excessive traffic of the obvious: combination and recombination of knowns, adorning and embellishing knowns. *(2; fall 1977)*

Today's snapshot genre of exploratory photography suffers from lack of imagination. The best that can be attributed to it is spontaneity. Conceptually it is old hat, something to which we are now thoroughly conditioned. Pursuit of the snapshot as a contemporary activity is not much more than a romantic longing for the simple.

The snapshot genre is weak because it is obvious. The image is determined by little more than the presence of the photographer. More is revealed of the objects photographed than about the photographer, regardless of the skill of the rendering.

Many of those photographers walking the streets, shooting from the hip, are interested in obtaining souvenirs. Their results indicate only change of time and place. The viewer is presented with signs, but nothing symbolic. As it occurs today, the snapshot is not pushing any frontiers; it holds little power within the medium. *(2; 1976)*

The construction of the camera presents us with a ready-made frame and a strong pressure to center, particularly if one's subject is singular. I want to take liberties with space, two-dimensional or otherwise. The problem as I see it is to find a unity in discontinuity, to integrate diverse elements. *(2; Egypt, 1976)*

The *camera* assumes authority by merely pointing. Consequently, whatever it points to takes on some special and increased value. The camera simultaneously points and awards value.

The *frame* can similarly be used as spotlight, pedestal, glass case, or drum roll for any object. These devices bring recognition, importance, or authority to the subject.

If one recognizes the power of the device, one has to be aware of the aptness in matching it with subject or content. The device can confer distinction but not necessarily meaning.

Light informs. Without it we could not distinguish, separate, or describe the features of the physical world.

Darkness sets us to finding the light. *(2; 1980)*

Instead of thinking of the camera as the transmitter or recorder, can it be the instrument that produces divisions, interruptions, separations, and discontinuity? Is it possible to think of the camera as the initiator or stimulator

of the event? *(2; 1976–1979)*

Paradox: Lives exist and are measured linearly. The trajectory is linear, a succession of points, yet we strive to embrace the whole. One struggles with specifics in order to affirm universals. *(2; 1980)*

Tragedy is failure in the face of possibility, the inability to communicate. For all the show of communication, the fact remains that one person does not fully understand any other. How many who survive years of cohabitation can say they understand their mate? *(5; 1975)*

Tragedy is unwanted change, loss, or destruction accompanied by the belief that somehow it could have been prevented.

It is as if one's premises are inadequate, false, or so distorted that they fail in the developing action, when the terms change midway. Thus one does not speak of tragedy in the death of one having lived to a full and ripe age. That occurs in premature termination where little of the preparation comes to harvest. The survivors must live with the sense of what might have been.

Other kinds of tragedy include:
so much to give, but rejected
preparing to do, but doing nothing
aspiring to do good, but doing wrong
the attainable, unattained. *(2; Greece, 1976–1979)*

Man-made barriers: duty, family, country, revolution, or abandonment to hedonistic pleasure.

Antidote: nakedness / truth. *(2; Greece, 1979)*

America pursues, flaunts, idolizes the new. This is the logical legacy of the immigrants, shipping across the sea to an unknown land, cherishing the notion that something better was possible. They dared to dream and then dared to realize the dream. American optimism – often viewed by outsiders as naïveté – is rooted in hope.

America loves to relate the success stories of the individuals who made it. The sons and daughters of success are the royalty of our society. The golden halos of our ikons encircle the heads of athletes, entertainers, astronauts. They embody our philosophy.

But not all Americans are so fortunate. The number of successes is only a small percentage of the total. The psychic hardship suffered in this system comes from

the emphasis on the individual. The pursuit of one's dream is an orientation to the interior. The terms of one person's dreams are not necessarily those of another's. Isolation in varying degrees is therefore a part of the experience. Many are troubled by this aspect and need to align with a herd.

Because America exalts change, it is geared for movement. The expression "he is on the move" is complimentary. The danger in movement comes from excess speed and loss of control; without limits or braking devices, accidents are inevitable. But it is not necessary to become stationary to attain stability. In ethics, man has found the means for balance and control.

There is danger when enrichment of one individual is at the expense of society. A system of individual rights is overextended when one can impair the movement of another; a system fails when an individual has to fear another. The problem lies with the interpretation of rights and freedom. It is irresponsible to think that freedom is license to act regardless of the effect on others. Any intent which brings harm or fear to others has to be questioned.

What would be the effect if our society could guarantee a life free from fear of attack? *(2; Egypt, 1976)*

To be born in America is to grow up with the world's dominant language, to be given a passport that allows virtually unrestricted travel, to have access to the most advanced technology, to have the widest selection of goods and services, to pursue the broadest range of interests. Ours is without question a privileged birthright.

America is opportunity spelled with capital letters. How pathetic that so many of its citizens fail to comprehend and appreciate their riches. The crime, the tragedy of the times, is the dissipation of that wealth. America puts much emphasis on comfort and play, the extent of which cannot be matched by any other country. But it is a burden to the development of youth, who are accustomed to the notion that all should come with guarantees and ease and that everything is merely a question of choice and taste.

The child of riches can make the sad mistake of thinking that – as a matter of course – all will be known, possessed, and experienced in a lifetime. The mistake is failing to recognize the necessity of restraint and sacrifice. The promise of everything begets nothing. *(2; Egypt, 1976)*

Education is empty if it does not speak of and for humanity. Education advocates the triumph of good over evil, of purpose over random being. It also professes the dignity of the individual. These ideals are realized through striving.

Education presumes change by way of growth. Effort is directed to an improved position. But youth resists this notion. Despite inexperience, youth argues for parity and acceptance. While still in high school, the student may engage in the acts and rituals of the parents. And the parents – indulging in their own

fantasies of youth – allow the distinctions of age to blur. The idea of maturation and growth is lost. *(2; 1980)*

Education cannot disregard the importance of discipline and must assume the role of leadership. *(5; 1962–1963)*

Education: seeing problems, measuring, weighing values. A process sensitizing the individual to see and to respond intelligently to his or her existence.

Culture: thought and feeling fed by education. *(5; 1978–1979)*

In education, crisis has to be encountered. I try to trip students by saying that everything is not all right and ask what they are going to do about it. The crisis perpetrates an awareness that their assumptions are inadequate. A person who doesn't grow hasn't met enough resistance. I tell students that they should think of graduate school as preparation to climb a mountain. First you have to be able to distinguish between mountains and molehills. The students need to make distinctions. Discussion and arguments sharpen their skills of perception.

The question is how much the teacher should force the issues. When is confrontation necessary and when is it best to walk away? Poor teachers hold the students' hands and avoid confrontation. For me, one of the best experiences is a challenging student who wants clarity. Then the student pulls out of the teacher what the student needs. *(3; November 1983)*

The thing I look for in students is a sincere regard for the medium. I expect the individual to revel in the sensations which photography is capable of delivering – enchantment, seduction, mystery, love, hate. I want them to feel that photography offers the means to build edifices, move mountains, change the tides, and cause the dull to glow. *(2; undated)*

I have always advocated the importance of structure, a notion that was challenged by students in the sixties. I still see the residual effects of that time, but experience has strengthened my own affirmation of structure and sequence. In my classes, structure is strongly emphasized through a progression of problems. It means introducing the student to fundamental models which at first appear simple and fragmentary. Problems are selected for their potential to expand into more complex issues and to develop confidence. *(5; 1976)*

My nominal subject is photography. Proficiency and commitment are the stated objectives. To this end the student is exposed to, and encouraged to work with, a range of photographic image-making concepts.

Of greater importance is making the student aware and enthused about the educative process as an ongoing activity and an essential determinant of their lives. My aims: respect for the educative process, a willingness to participate, a desire to discover, bringing out something of the student's potential and giving them a sense of the value of their quest. *(5; 1976)*

With bright, ambitious students who will work, the teacher also has to have a vision, something larger than personal ends. *(3; 14 December 1982)*

To work with students is to give and give without much confirmation of what or how much is getting through. A delicate line exists between the extra measure that moves the student and that which exhausts the teacher. *(2; 1970)*

Thought and Action are the working couple of art and life. If only students could understand how action proceeds from and is dependent upon mental activity. The best that the student could do for his or her own development is to exercise the power of consciousness. Identify an idea and then make it as convincing, vivid, and intense as possible. Don't settle for interesting, pretty, or acceptable pictures. Ideas energize; imitations enervate. *(2; 1976–1977)*

With the youth and limited experience of the student, there exists a desperate need for motivation, understanding, and discipline. It is not the mature exchange of ideas.

Do we work to monumentalize the sure, or do we attempt to give breath and encouragement to some incipient thought or feeling? *(2; 1 February 1970)*

Students are all too eager to apply terms of significance and meaning to their activities. They become facile in the use of heavy words. It is preferable to keep them away from those terms, for lack of experience can make for hollow, inappropriate judgments. It is more important for the student to be involved in the process than to worry about final judgment. *(2; 1979)*

Judgmental terms come to haunt us: "good" and "bad" cannot be permitted to inhibit the artist. Our duty is to produce according to the honest dictates of the self and not to the prescription of overseers. *(2; New Mexico, 1970)*

Lacking most conspicuously from student work is nuance. The student doesn't entertain the subtleties, the unknown, the unpredictables which provide the flavor and the emotion. *(5; 1965)*

Familiarity breeds nuance. *(5; 1977)*

Beginning students are disadvantaged because they don't see the richness of the

medium. They are too absorbed in superficial elements and narrow concerns. Whether there is push and pull in a piece is the measure.

Making notations may be important to the maker but has no meaning to anyone else coming to the work. A mark is made; something is spelled. If it is too little it has no life. *(3; July 1983)*

Students are afraid to act. If they could only know that the pure act – the act of desire, of innocence – carries its own immunity. *(5; 1967–1968)*

Photographing is a process dependent on a series of programmed components. Therefore a course of study attempts to present the parts, to understand the function of each part and then its potential, and to see patterns or systems in which the parts combine. *(5; 1978–1979)*

A graduate program should provide the atmosphere for self-realization and the development of ideas. There is no proclaimed vocational end; it should not just aim for teaching or professional concerns. To state such a specific goal circumvents the central and essential experience. *(2; Greece, 1979)*

The "good life" as a model falls short when it is based only on materialistic gains and printed credentials. They can constitute a goal and the means of getting them are open to corruption. Where there is no humanistic consideration or contribution, there is no significant integrated experience; no growth is required. The line-up of goods is not a substitute for a full life.

When the "good life" is measured in terms of humanity, the means carry more value than the result. Work is of a constructive nature and requires ongoing attention. To be involved is a constant struggle to define and orchestrate a complex organism. It can be no other than an integrated activity. *(2; 1980)*

It is interesting what poles the character is stretched between. Mine are hope and despair. I think of it in religious terms. There is a god around which the world revolves, but it is not the traditional sixteenth-century God. Today, with more emphasis on the psychological, we deal with other masters who are just as much over us. Ours is the existential dilemma: hope and despair, being and nothingness. *(3)*

Another polarity in my work is trying to confront human problems versus giving over to formal invention; a bearing down in the city and asking what is here, what is important, versus the flight of imagination. After a big dose of the city in the *Philadelphia* series, I started the *Composites* series. After my current city project, *City Whispers*, I will do something inventive. *(3)*

Thoughts and decisions can take you deeper into quality. There is the dream of wanting to do something better and more meaningful with one's life and giving

that dream form and a sense of order. When I look back, I see I was willing to gamble on the possibility of something better, that I could get just a little more nourishment if I made a decision. *(3; 1980)*

Because the act involves risk, courage is required. Without direction, proceeding is extremely difficult, if not impossible. Direction, or instruction, implies sources outside. Vision suggests from within. If one cannot see the problem, proceeding is hopeless. *(2; Greece, 1979)*

You make the work and people start looking and responding. In time, someone comes along who wants it. *(3)*

Chicago 1957–1959
The Loop 1957–1958

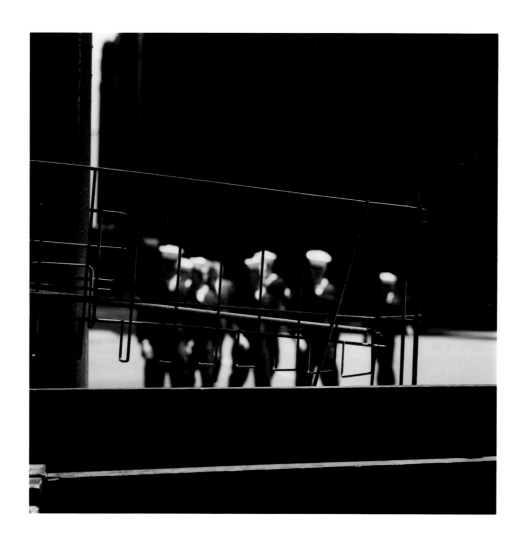

The Loop: Chicago, 1958

25

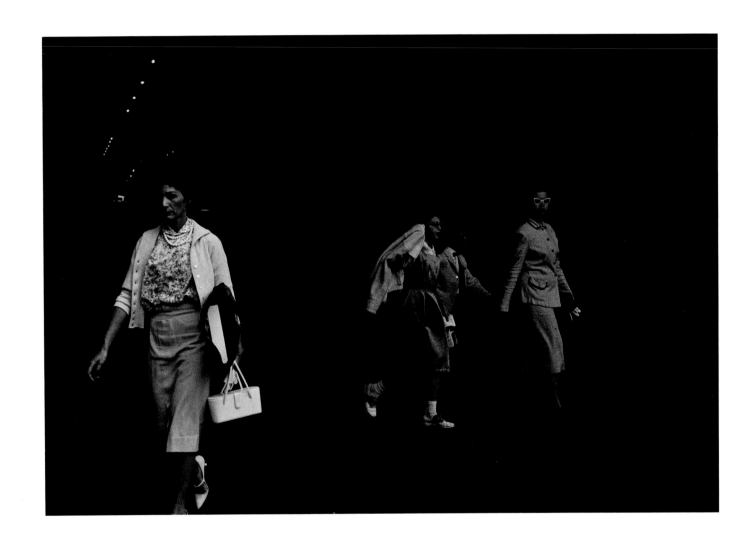

The Loop: Chicago, 1958

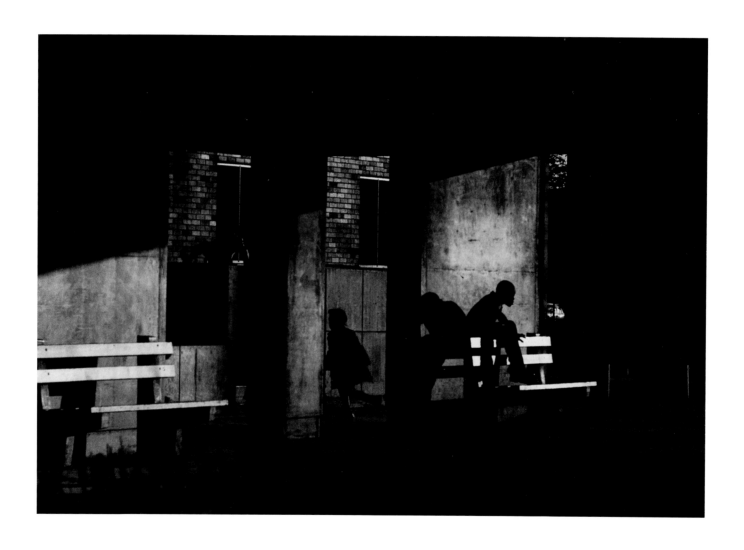

Chicago, 1958

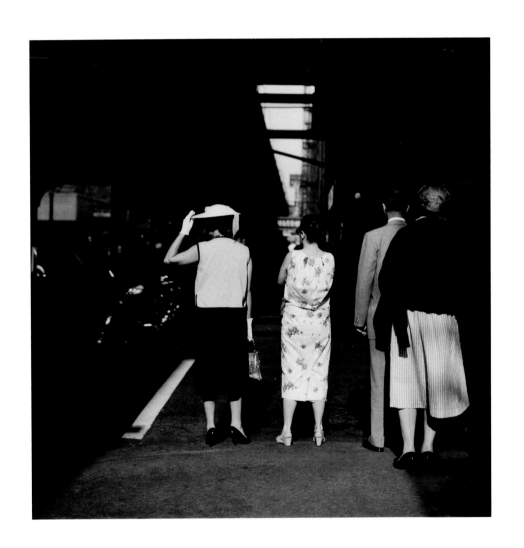

The Loop: Chicago, 1958

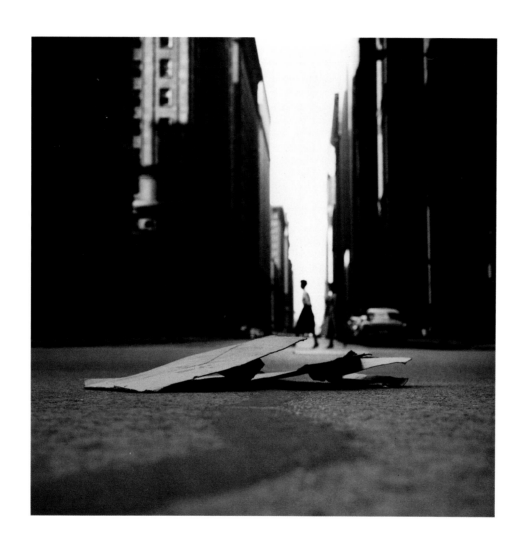

The Loop: Chicago, 1958

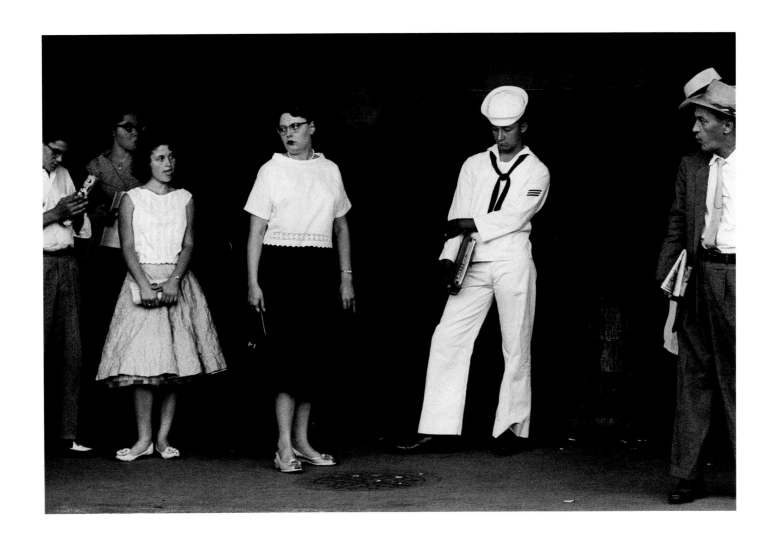

Chicago, 1959

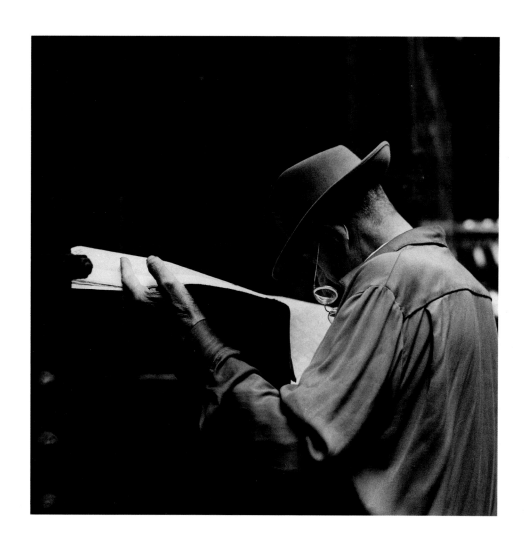

The Loop: Chicago, 1957

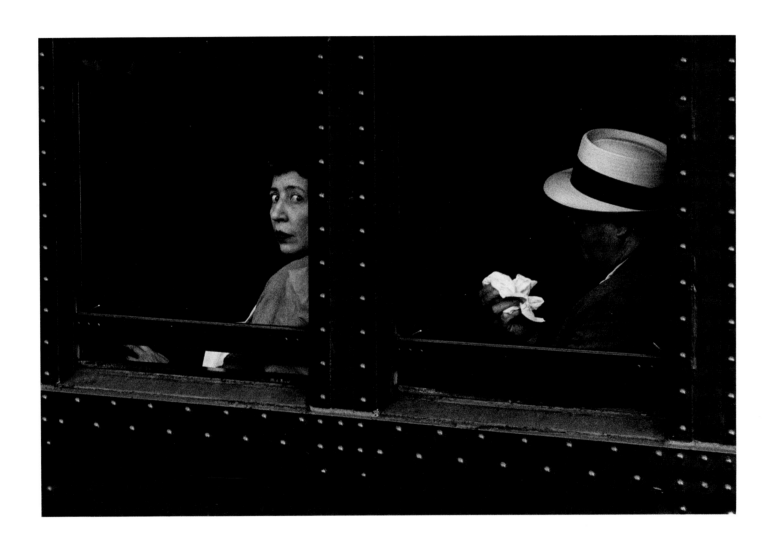

Chicago, 1959

The Loop: Chicago, 1958

33

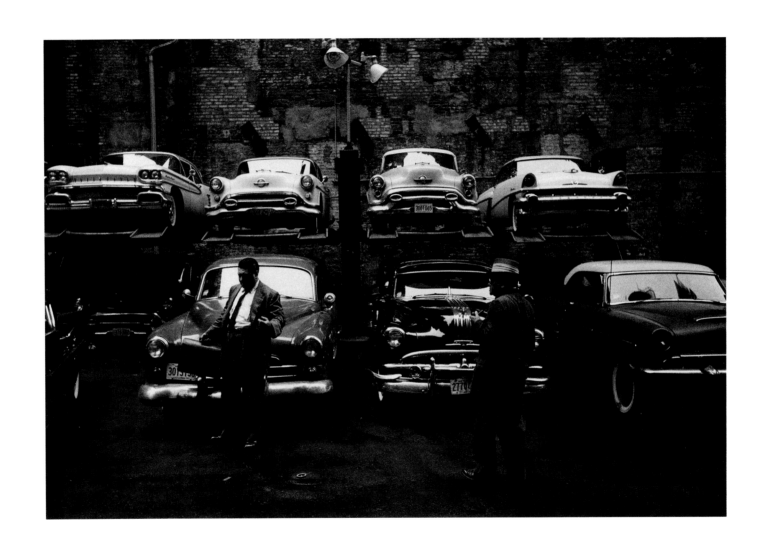

The Loop: Chicago, 1958

34

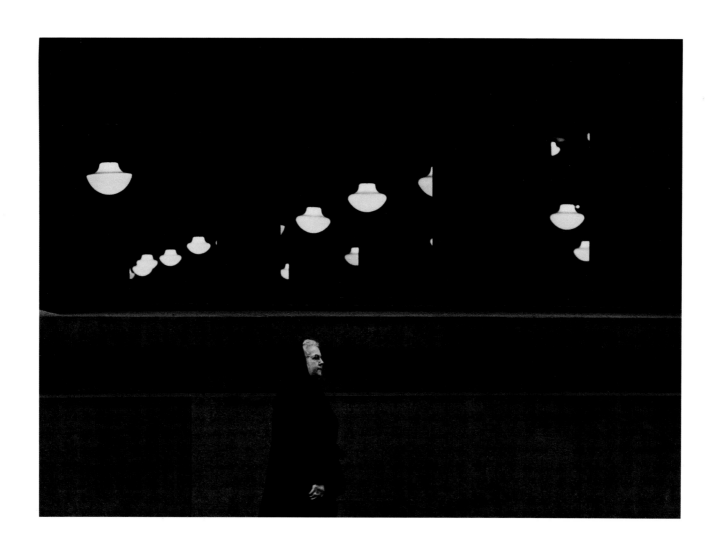

The Loop: Chicago, 1957

35

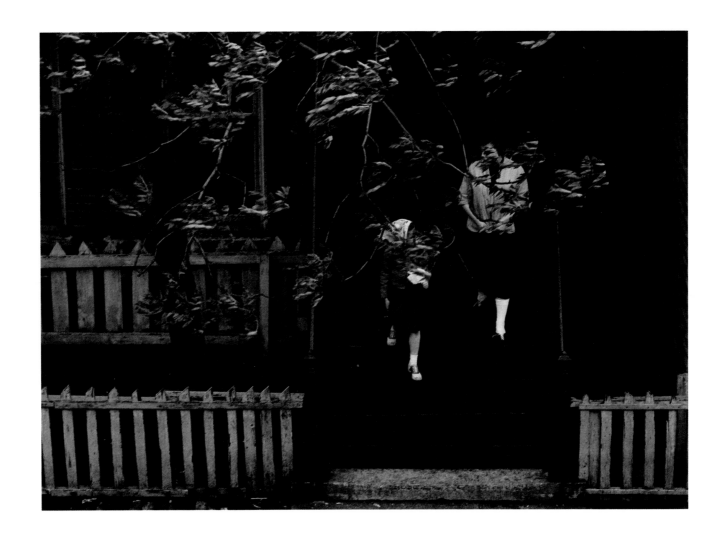

Chicago, 1958

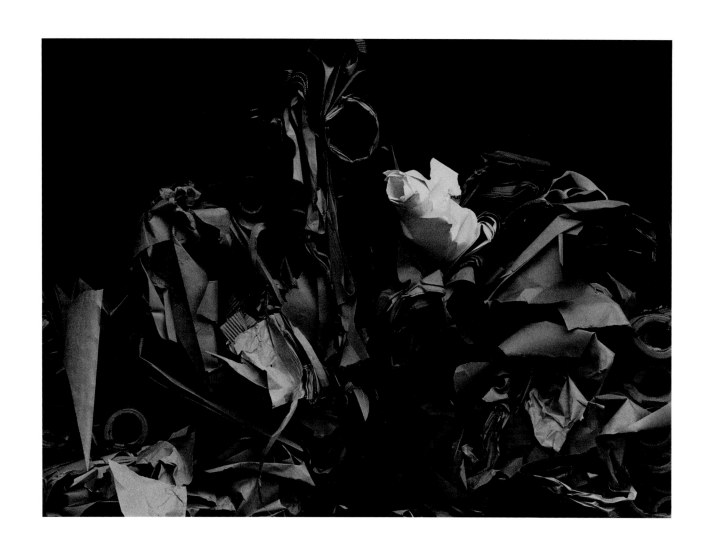

Chicago, 1959

Europe 1960–1961

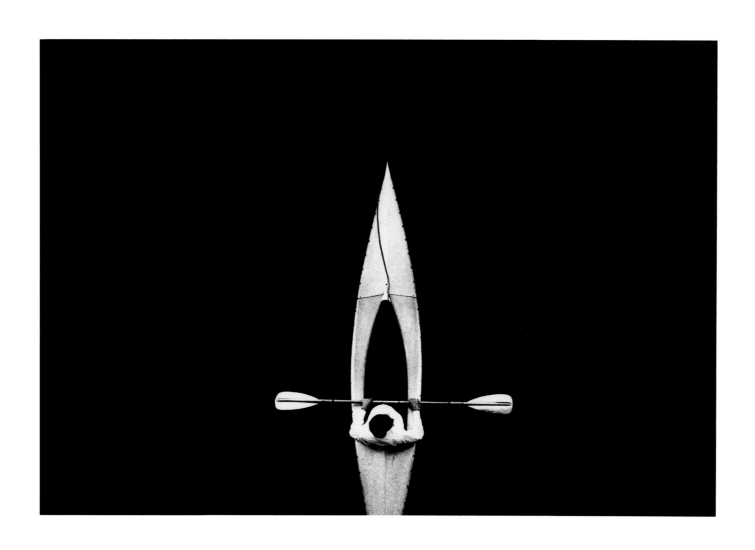

Europe: Frankfurt, 1961

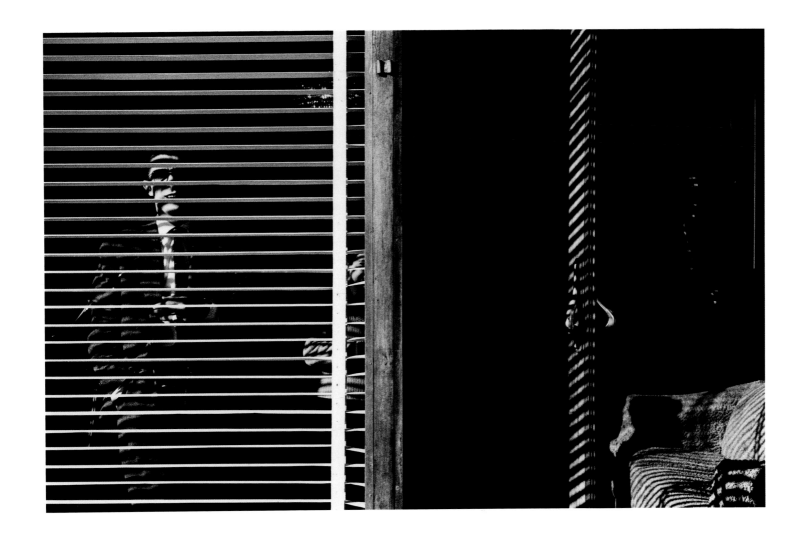

Europe: Alicante, Spain, 1961

40

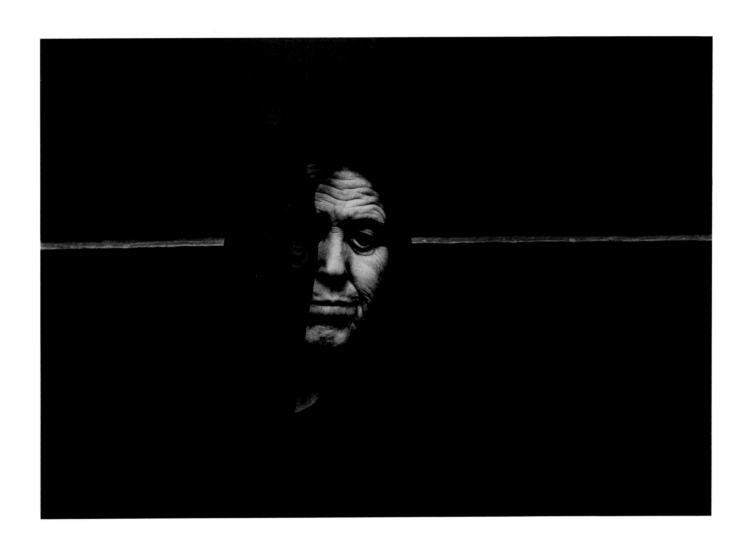

Europe: Almería, Spain, 1961

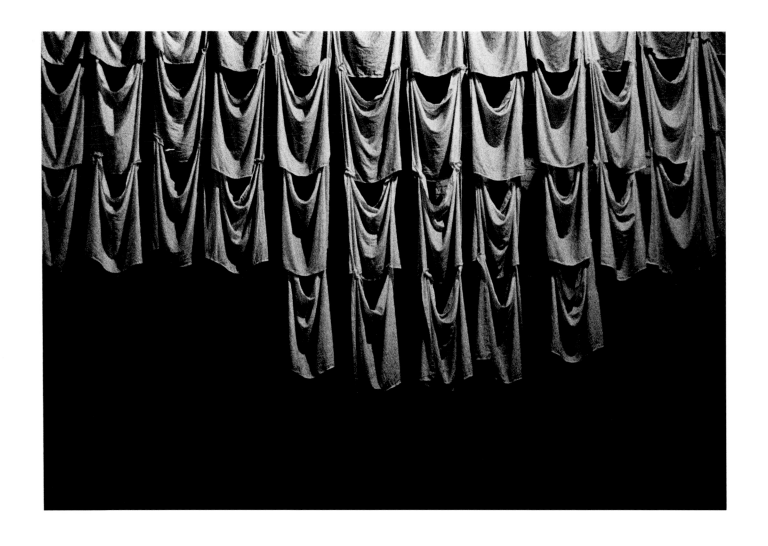

Europe: Venice, 1960

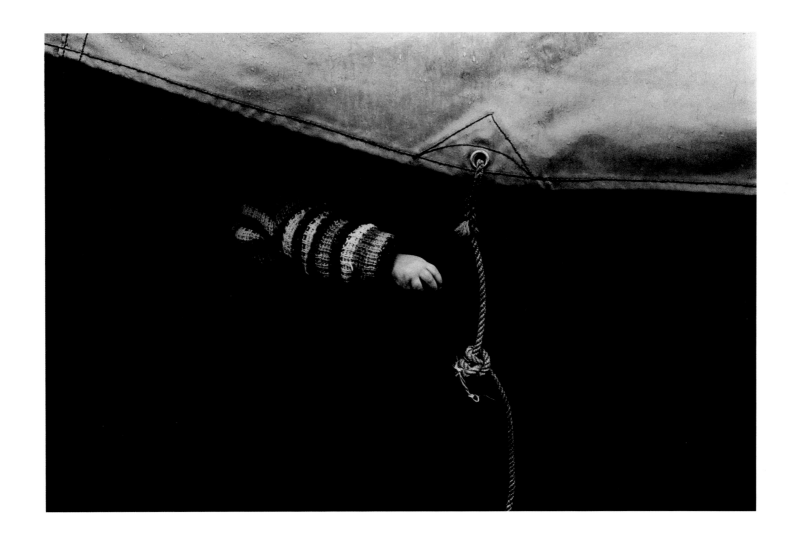

Europe: Portugal, 1960

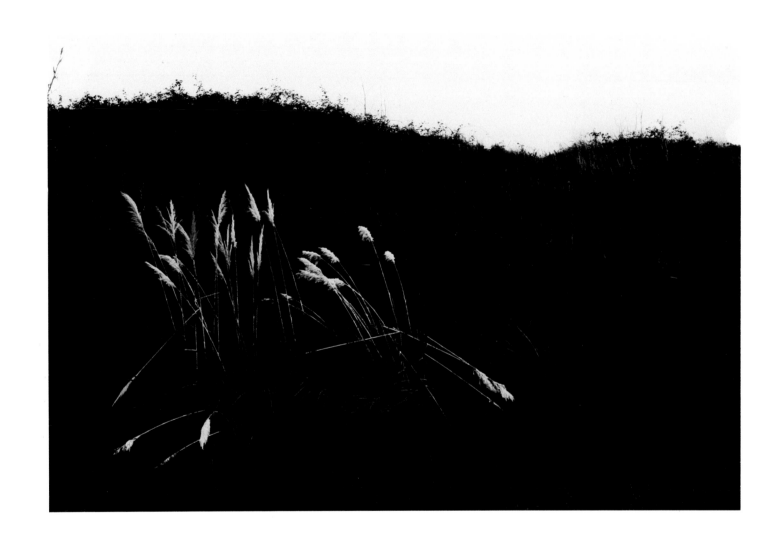

Europe: Spain, 1960

44

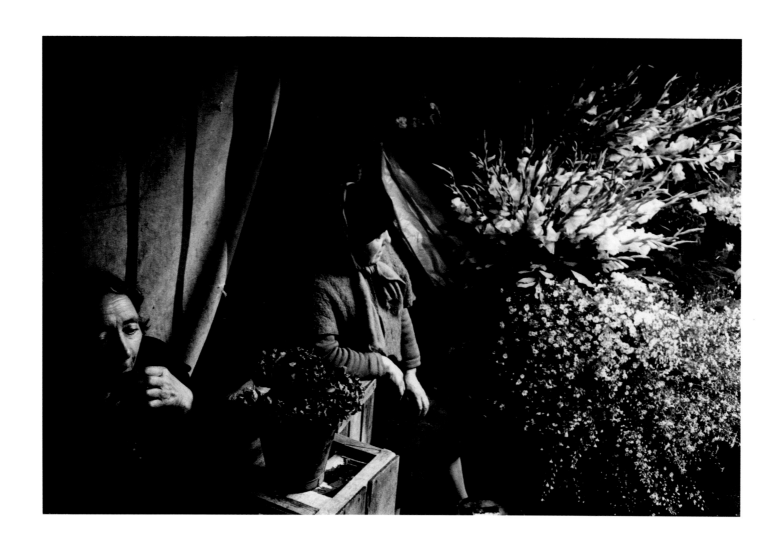

Europe: Bordeaux, 1960

45

Philadelphia 1962–1964

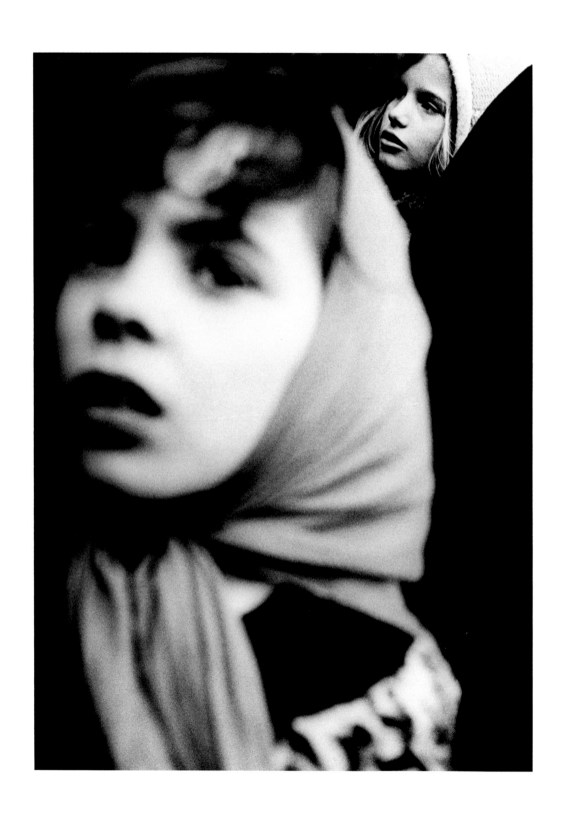

Philadelphia, 1964

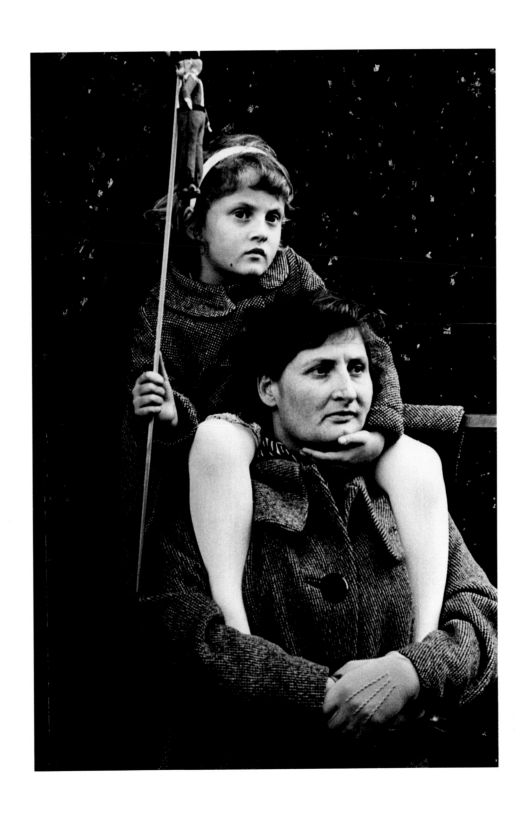

Philadelphia, 1963

48

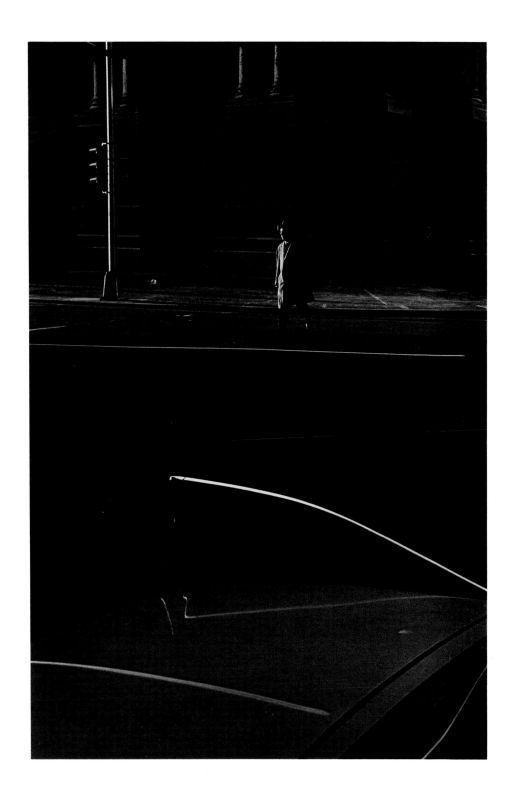

Philadelphia, 1964

49

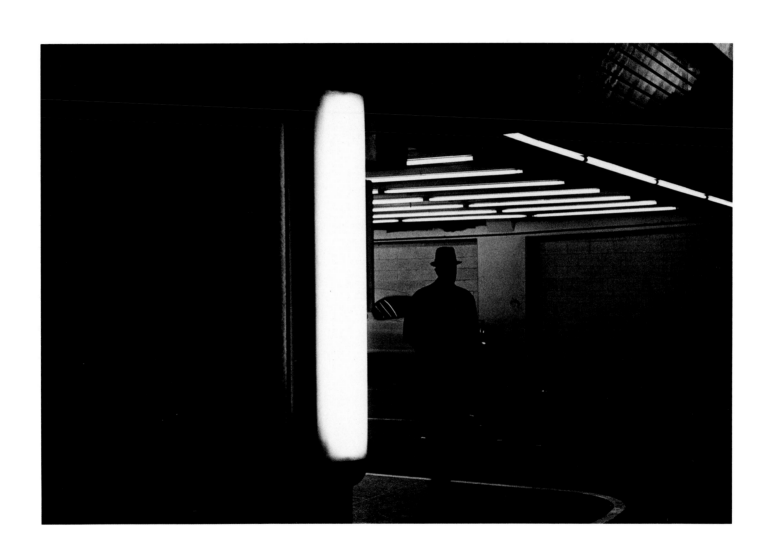

Philadelphia, 1963

50

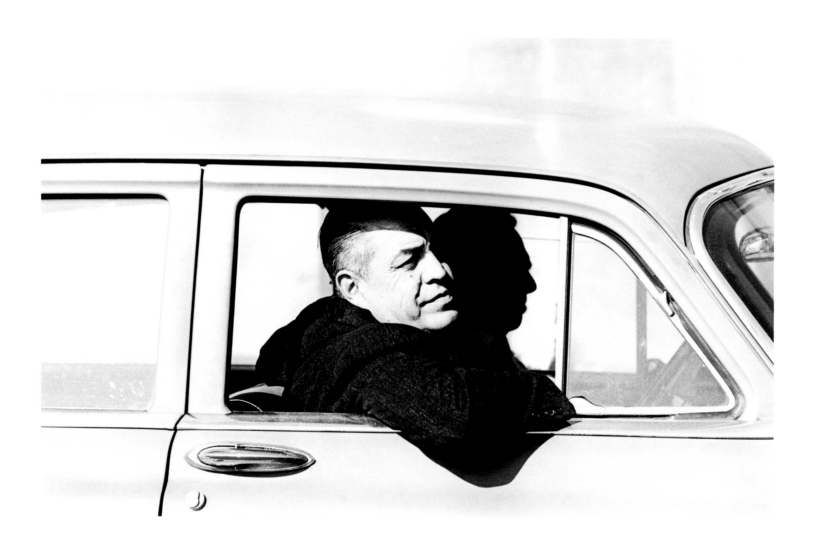

Philadelphia, 1964

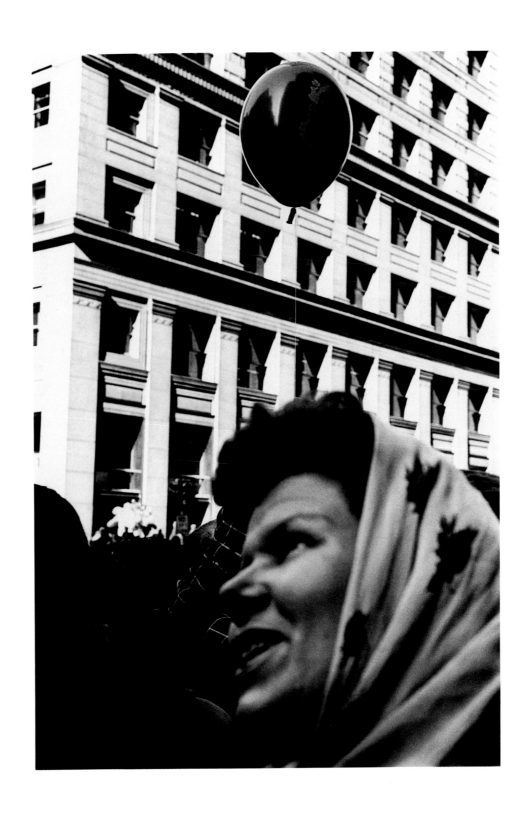

Philadelphia, 1963

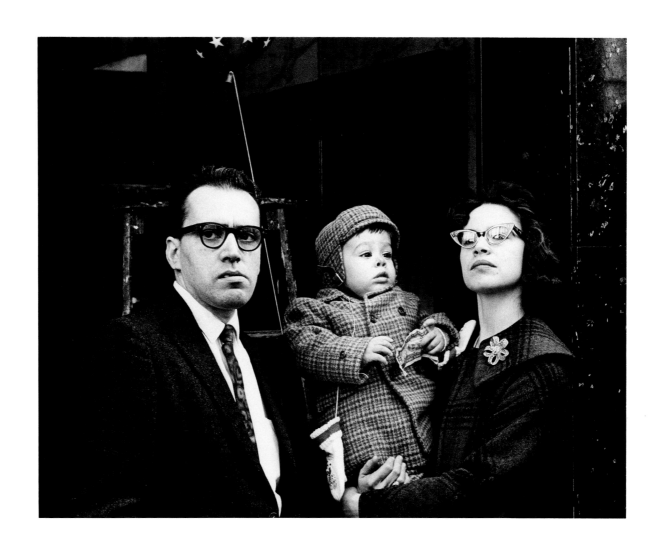

Philadelphia, 1963

53

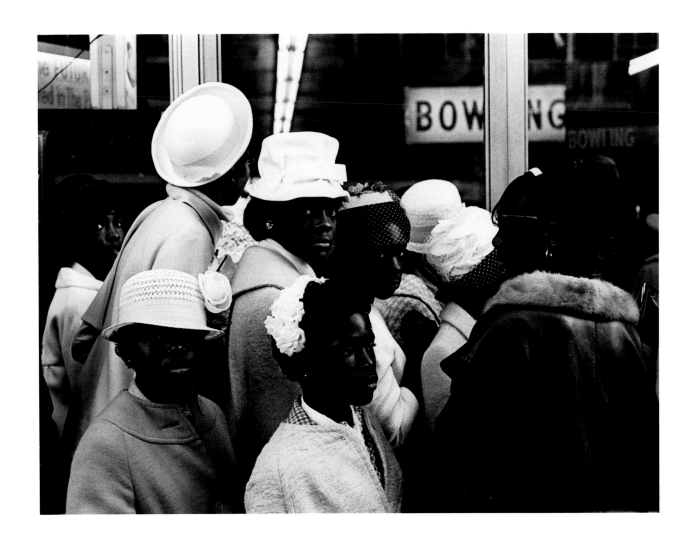

Philadelphia, 1964

54

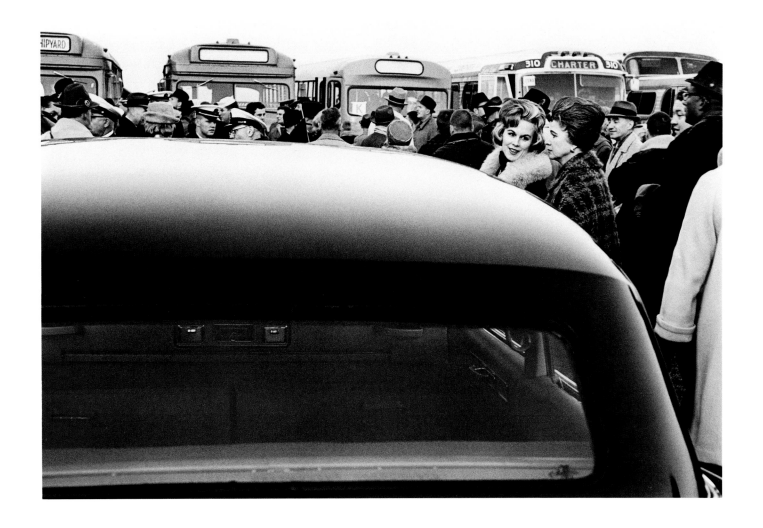

Philadelphia, 1963

Double Frame 1964–1966

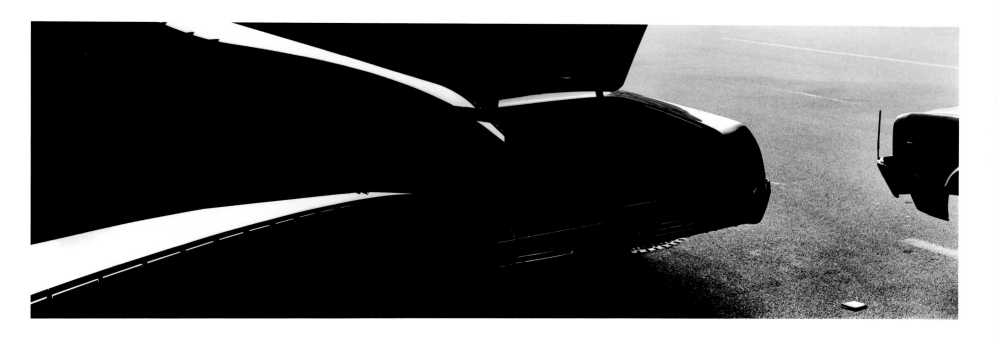

Double Frame: New York City, 1966

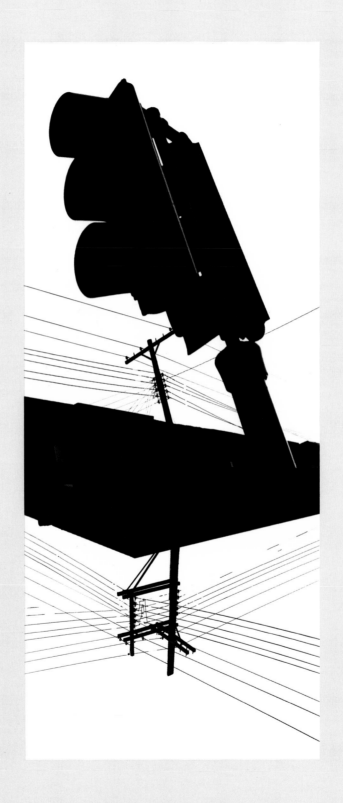

Double Frame: Philadelphia, 1965

Double Frame: Philadelphia, 1965

Double Frame: Philadelphia, 1965

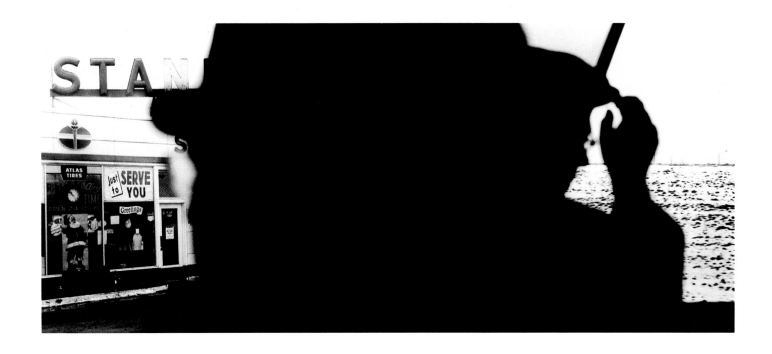

Double Frame: Wisconsin, 1964

Composites 1964–1984

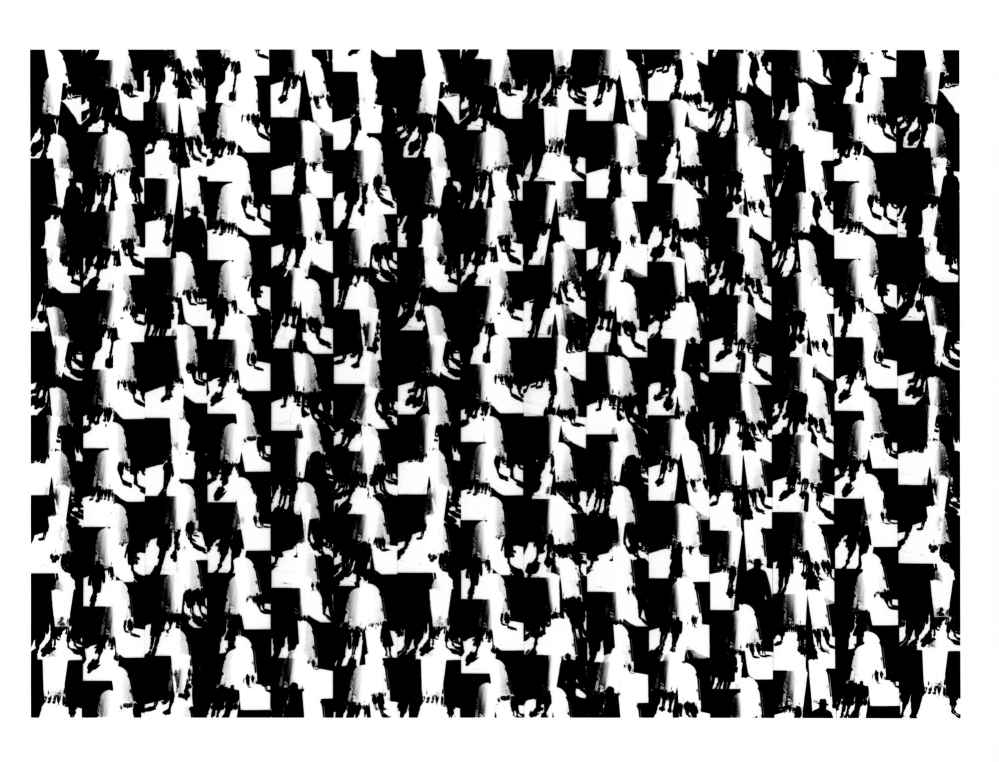

Composites: Philadelphia, 1967
(detail, pages 64–65)

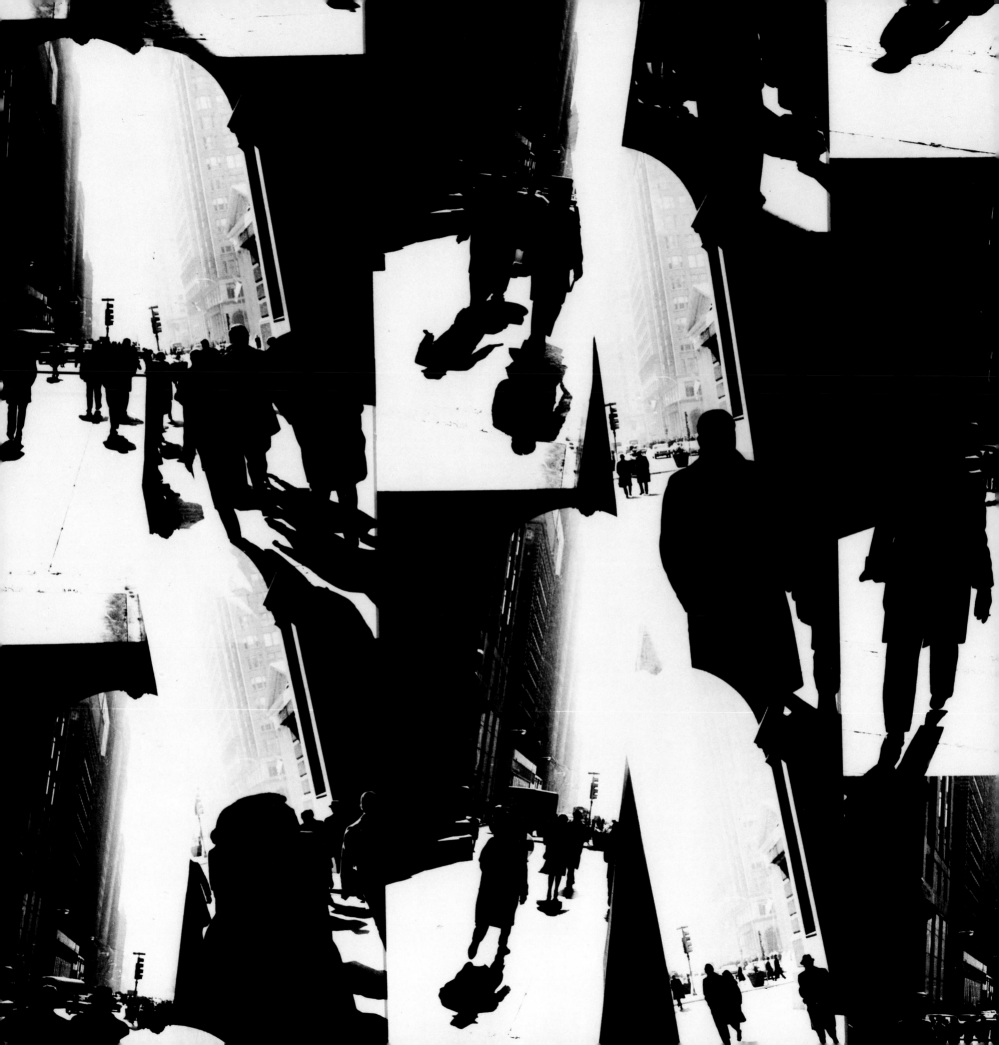

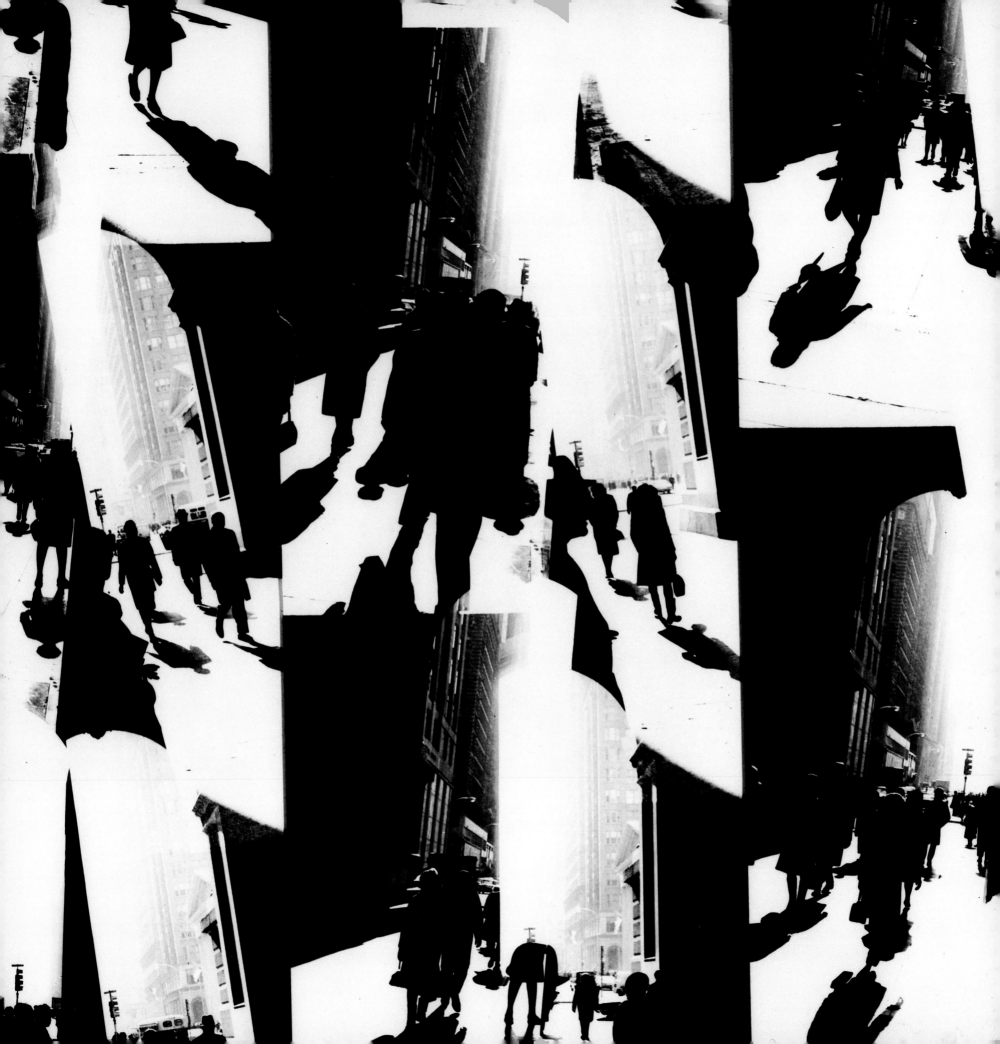

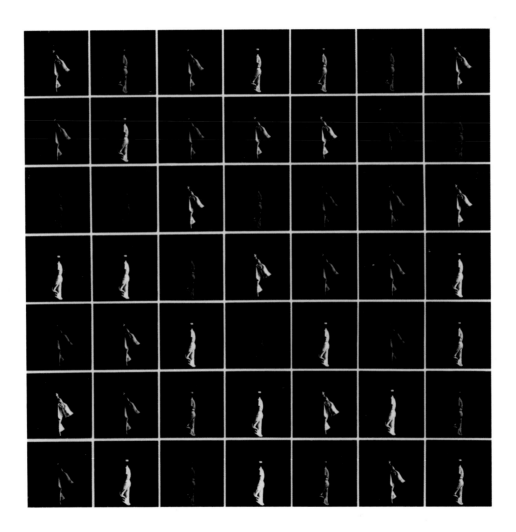

Composites: Philadelphia, 1964

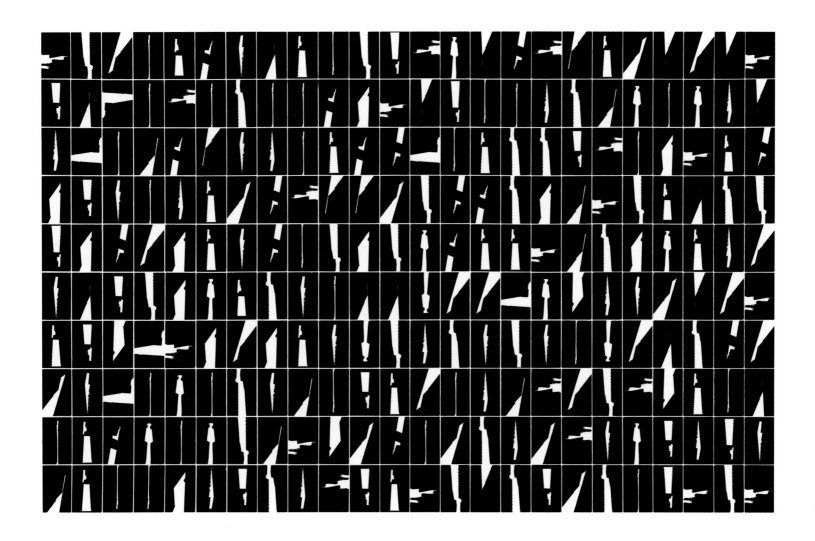

Composites: Philadelphia, 1965
Composites: Philadelphia, 1966 (page 68)
Composites: Spruce Street Boogie, 1966 / 1981 (page 69; detail, pages 70–71)

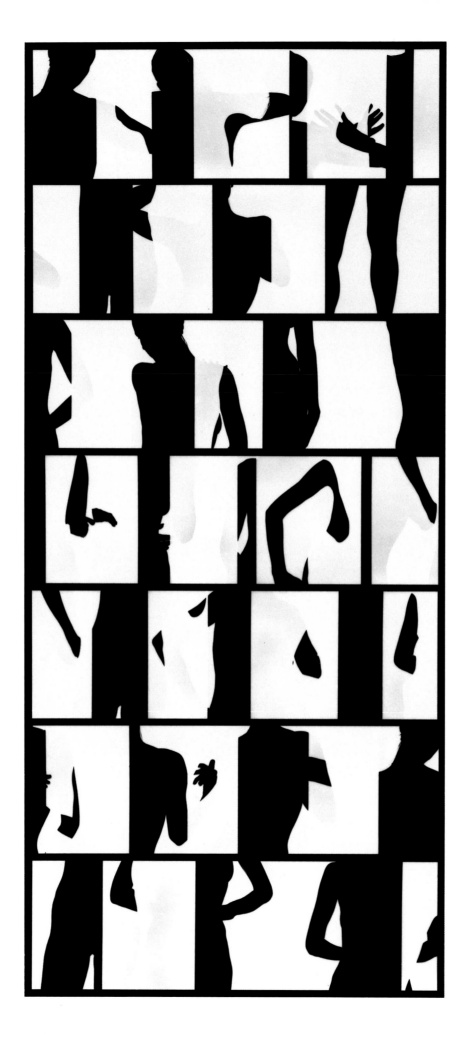

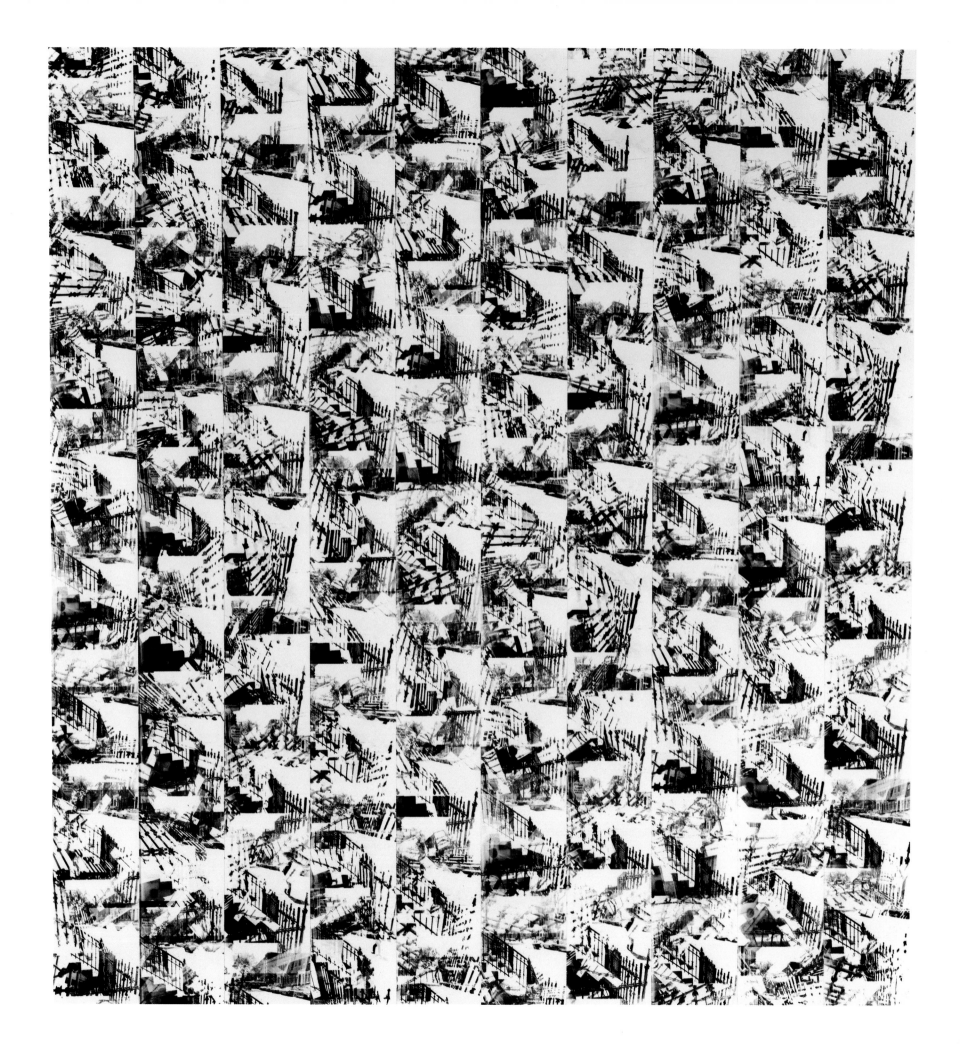

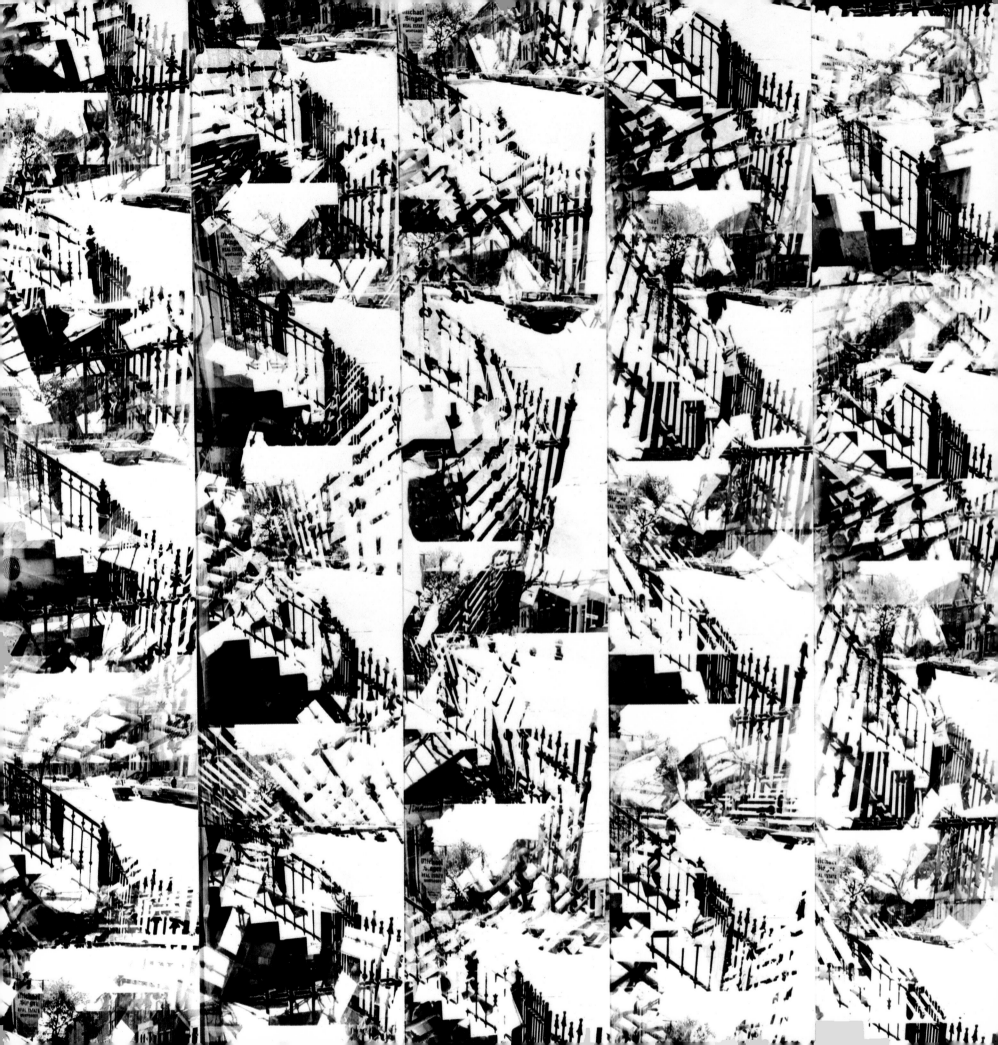

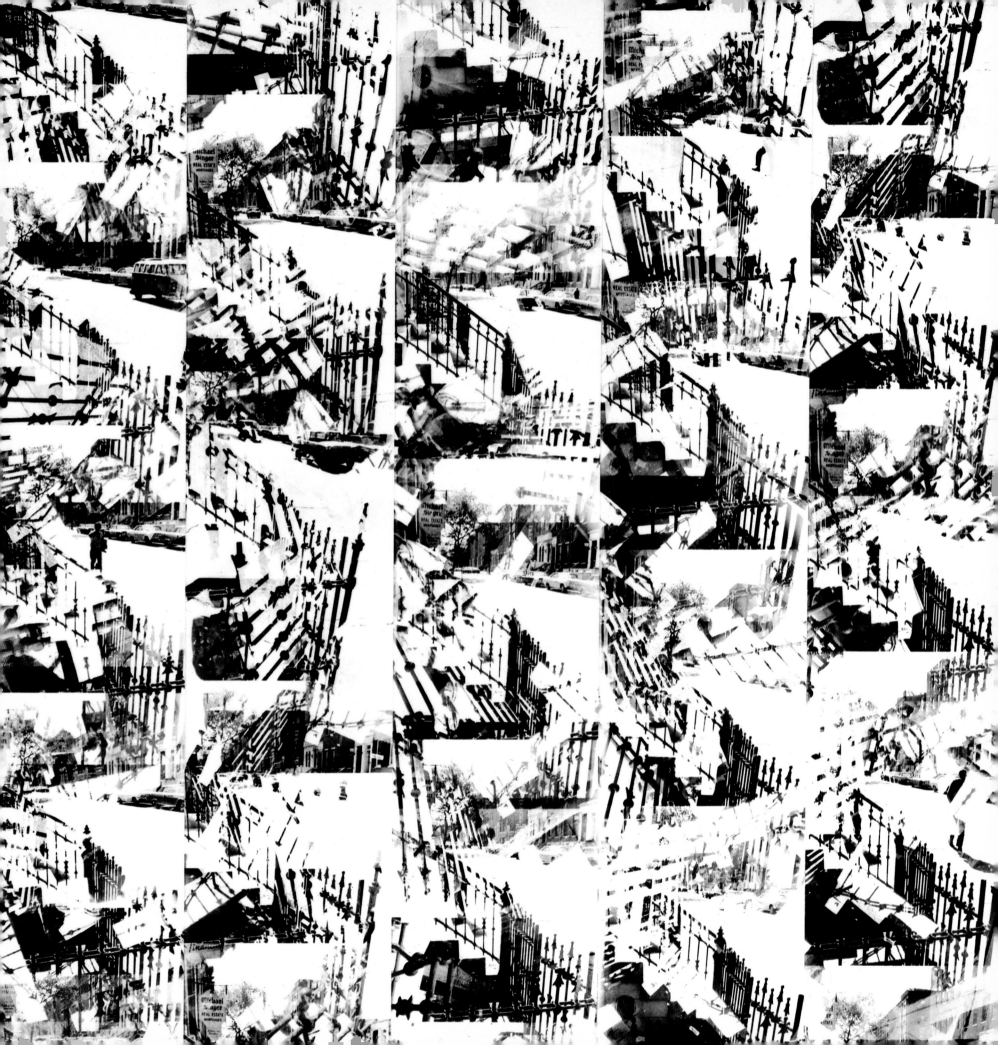

Couplets 1968–1969

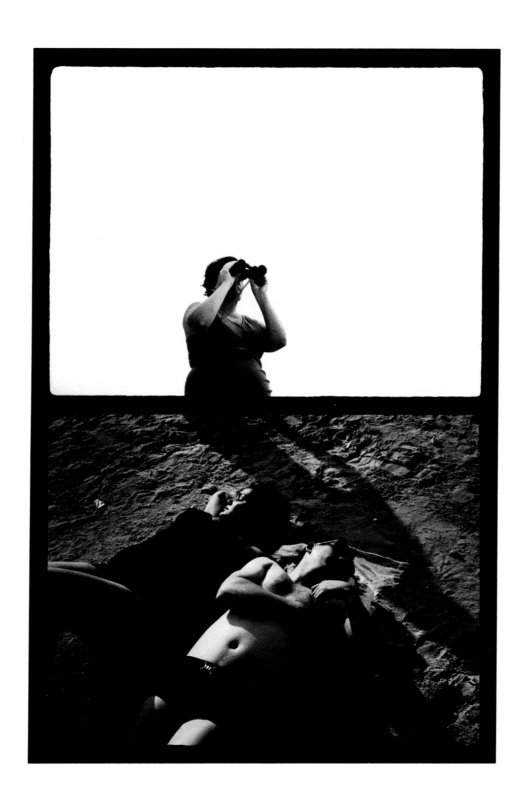

Couplets: Atlantic City, 1969

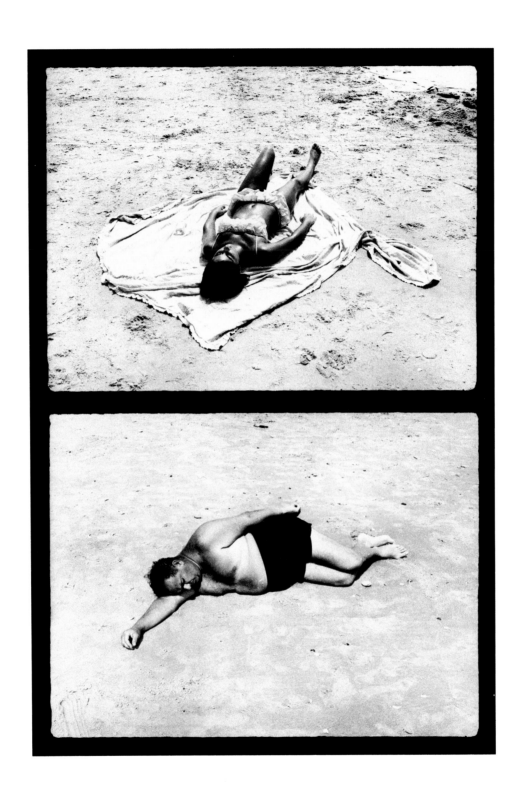

Couplets: Atlantic City, 1968

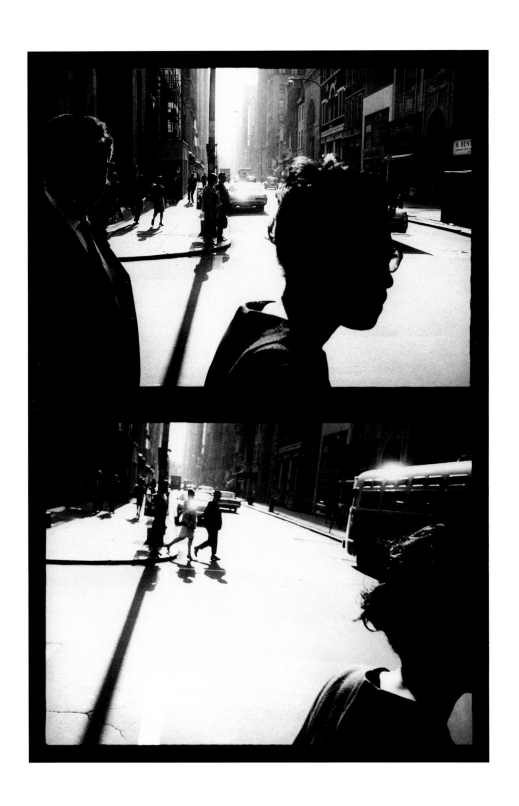

Couplets: Philadelphia, 1968

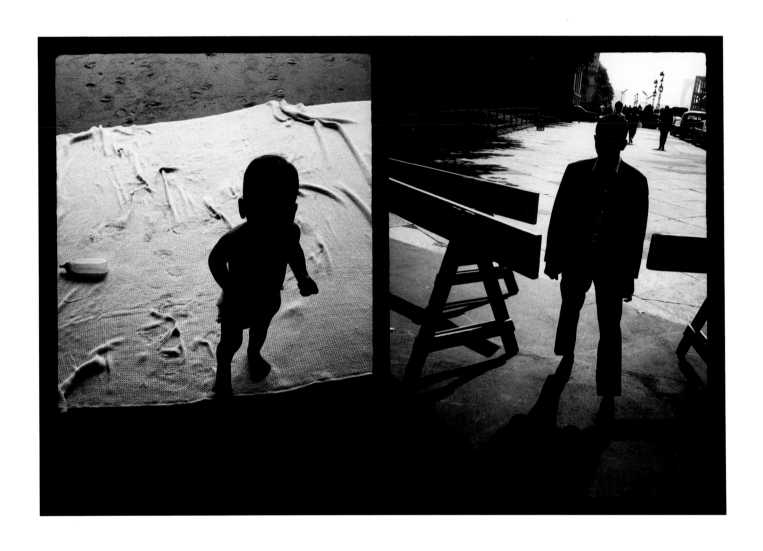

Couplets: Atlantic City / New York City, 1968

76

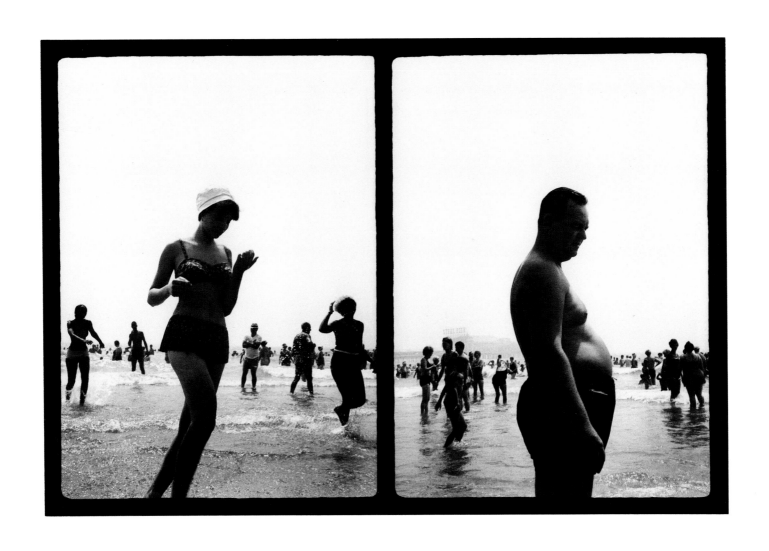

Couplets: Atlantic City, 1968

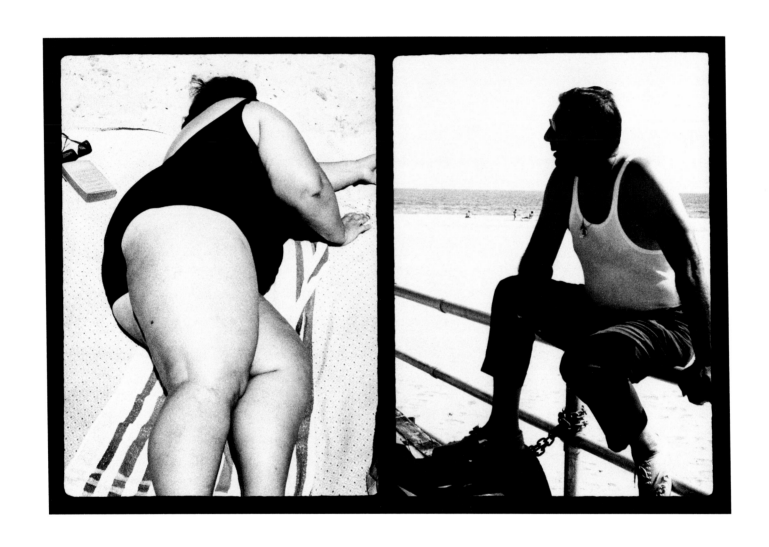

Couplets: Atlantic City, 1968 / 1969

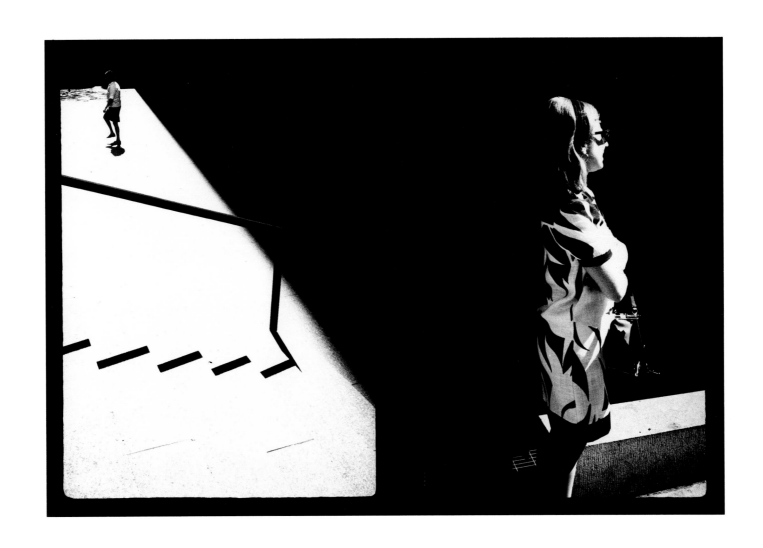

Couplets: New York City, 1968

Sand Creatures 1968–1977

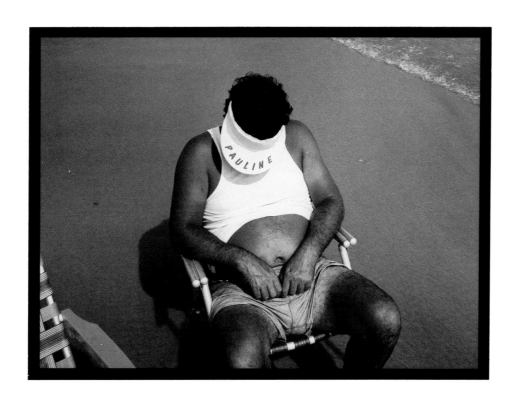

Sand Creatures: Wildwood, 1975

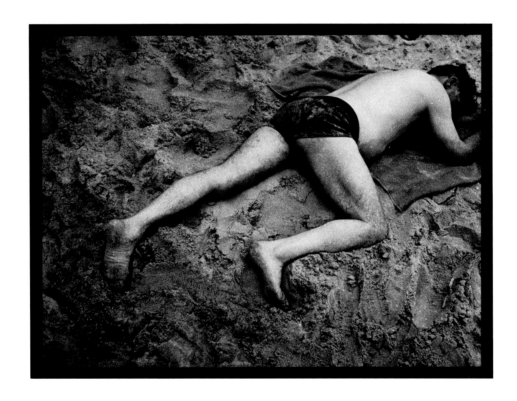

Sand Creatures: Atlantic City, 1971

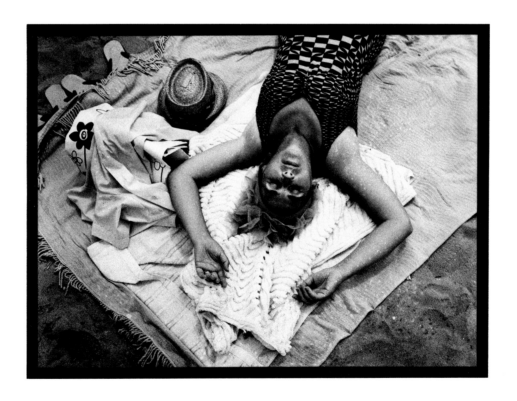

Sand Creatures: Atlantic City, 1975

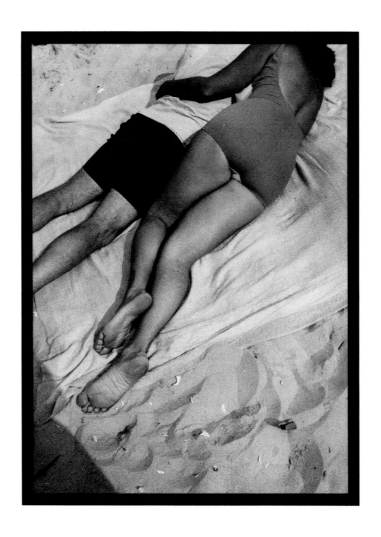

Sand Creatures: Atlantic City, 1973

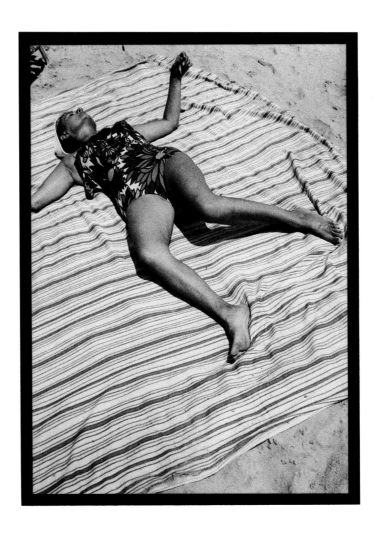

Sand Creatures: Atlantic City, 1975

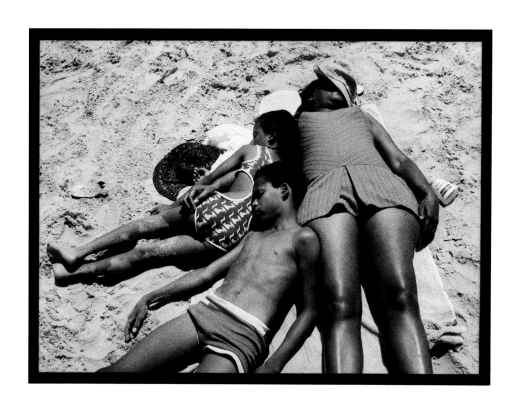

Sand Creatures: Atlantic City, 1975

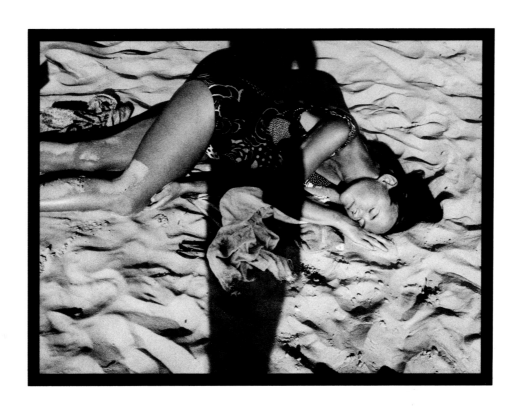

Sand Creatures: Cape May, 1973

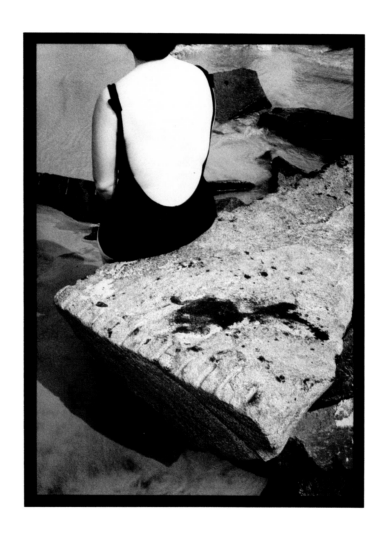

Sand Creatures: Atlantic City, 1969

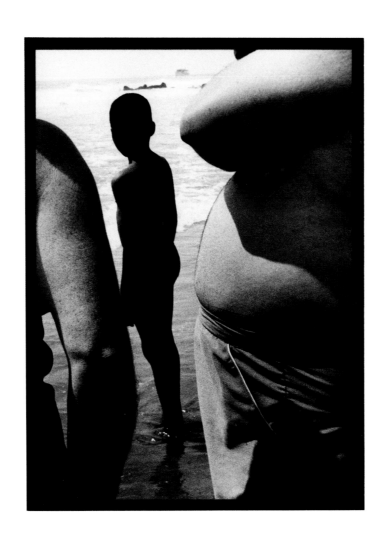

Sand Creatures: Atlantic City, 1969

New Mexico 1971–1972

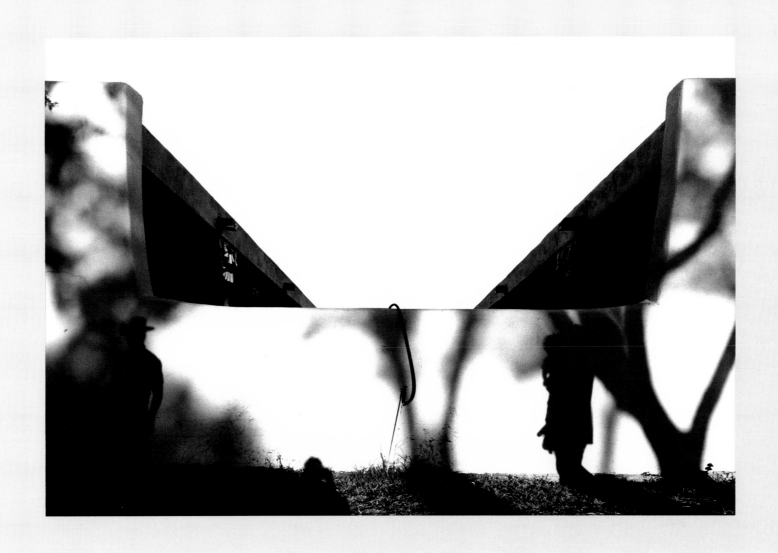

New Mexico: Albuquerque, 1971

91

New Mexico: Albuquerque, 1972

92

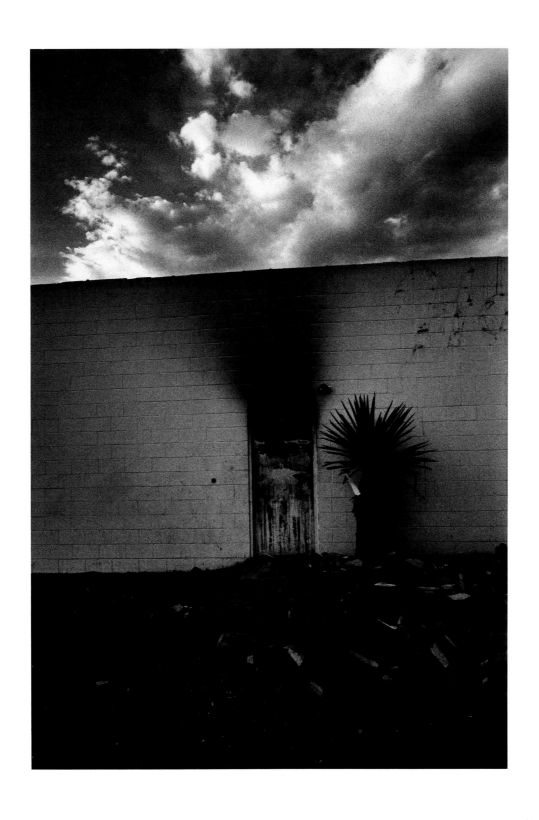

New Mexico: Albuquerque, 1972

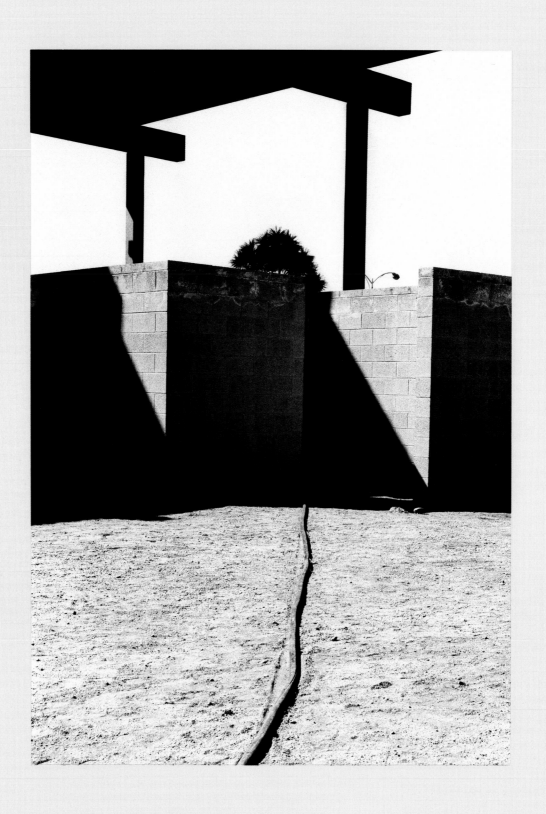

New Mexico: Albuquerque, 1972

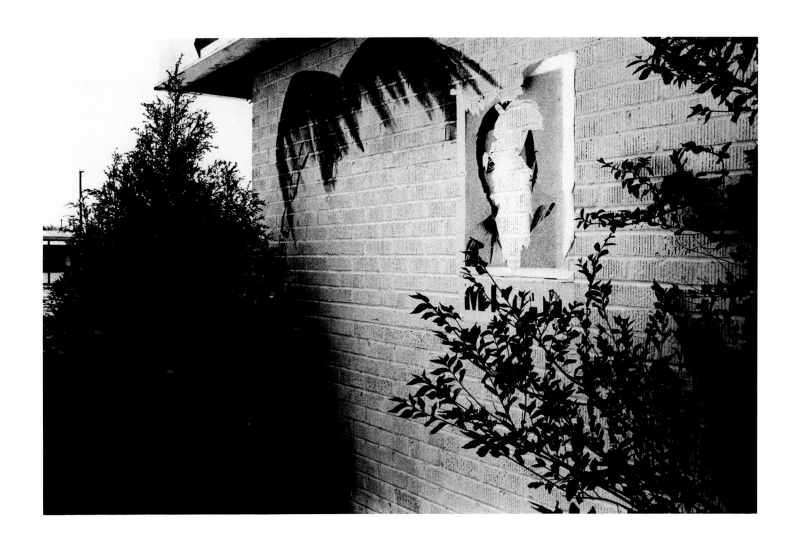

New Mexico: Albuquerque, 1972

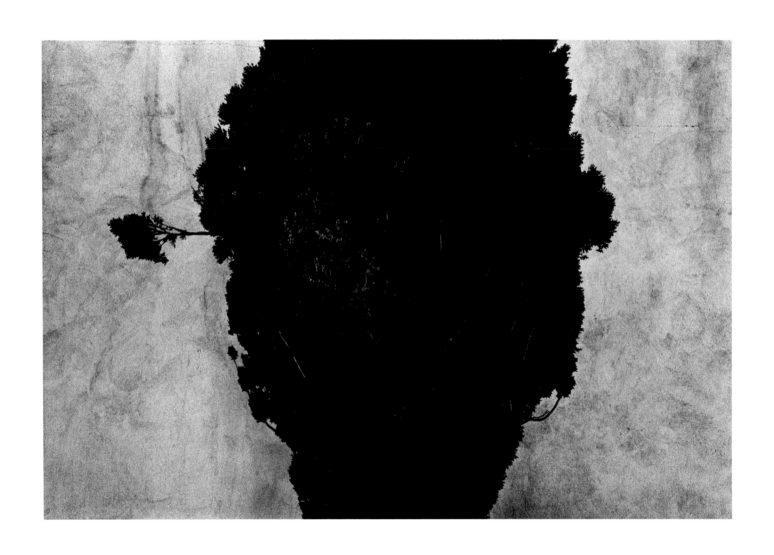

New Mexico: Albuquerque, 1972

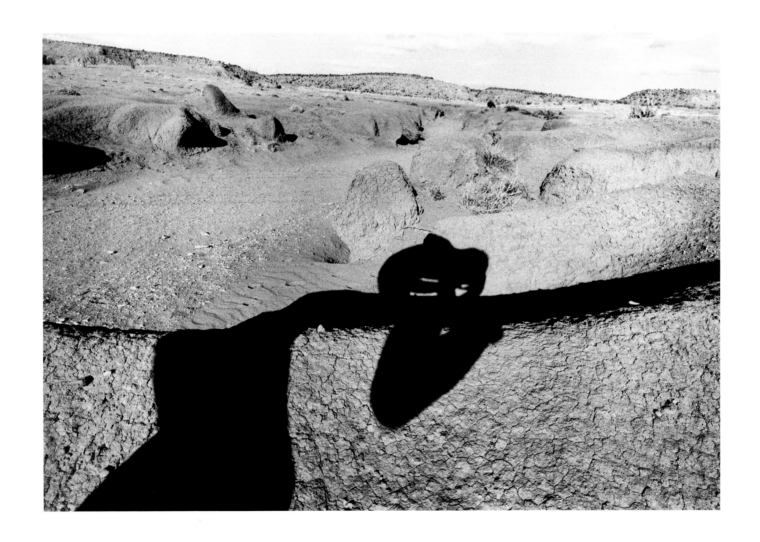

New Mexico, 1971

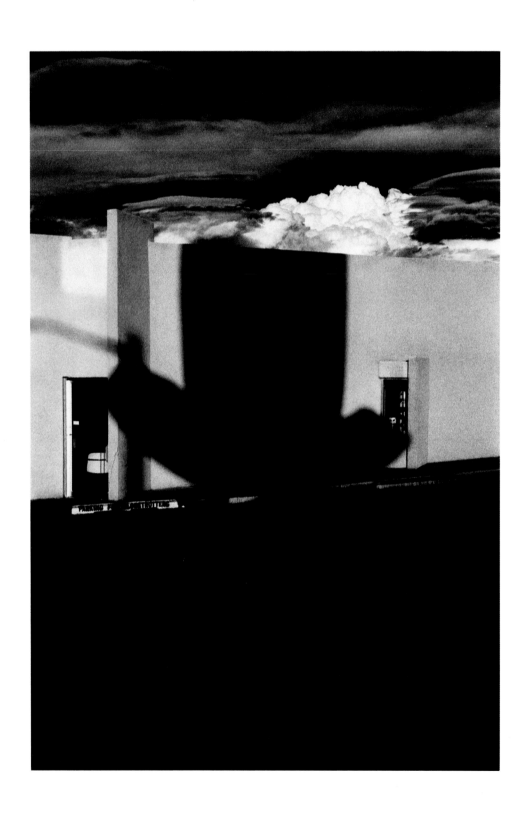

New Mexico: Albuquerque, 1972

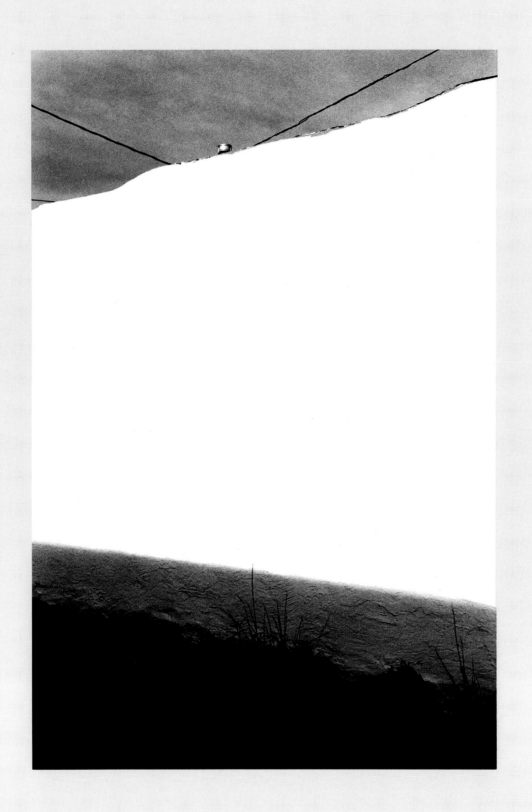

New Mexico: Albuquerque, 1972

Pictus Interruptus 1976–1980

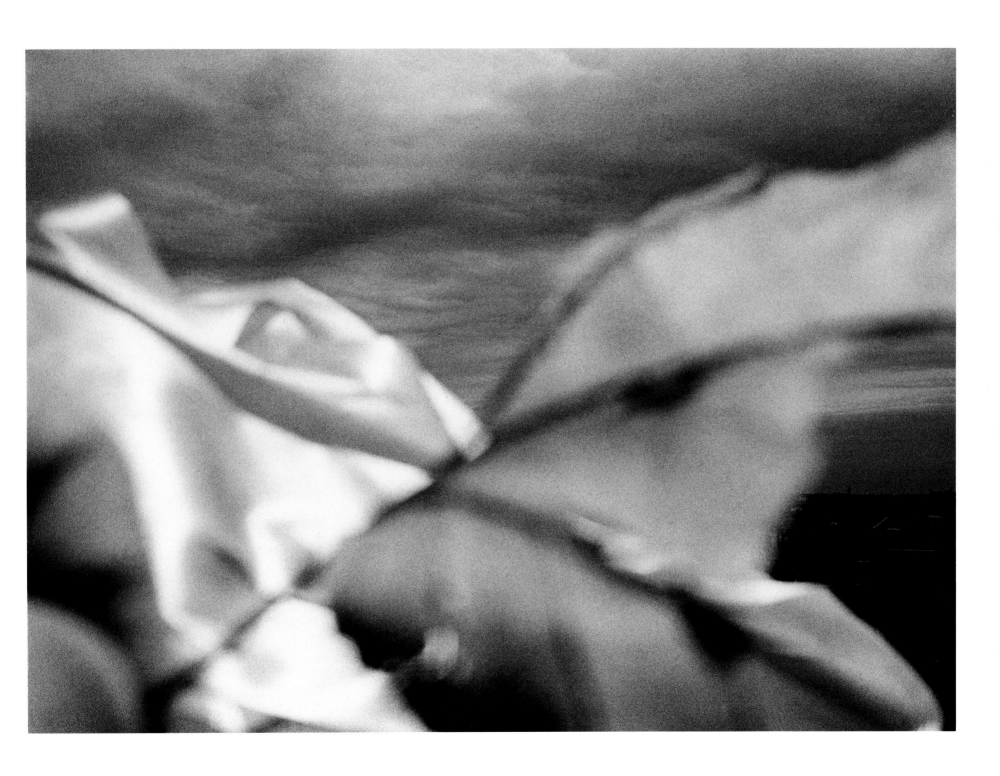

Pictus Interruptus: Philadelphia, 1980

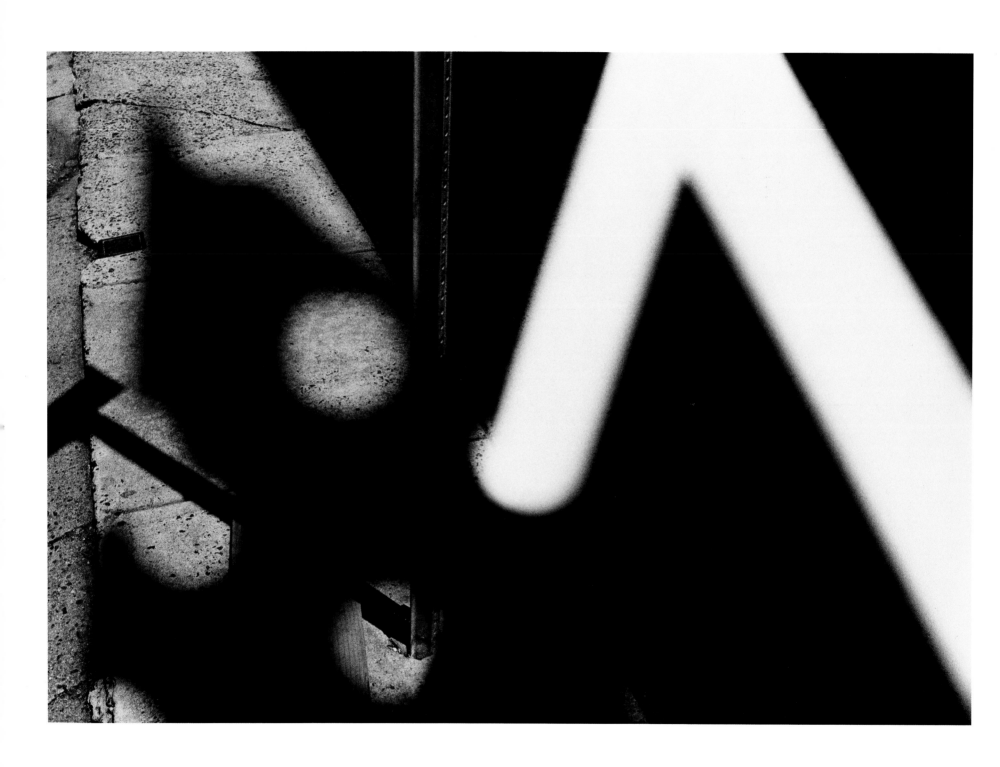

Pictus Interruptus: Spring Tingle, 1980
Pictus Interruptus: Philadelphia, 1977 (right)

102

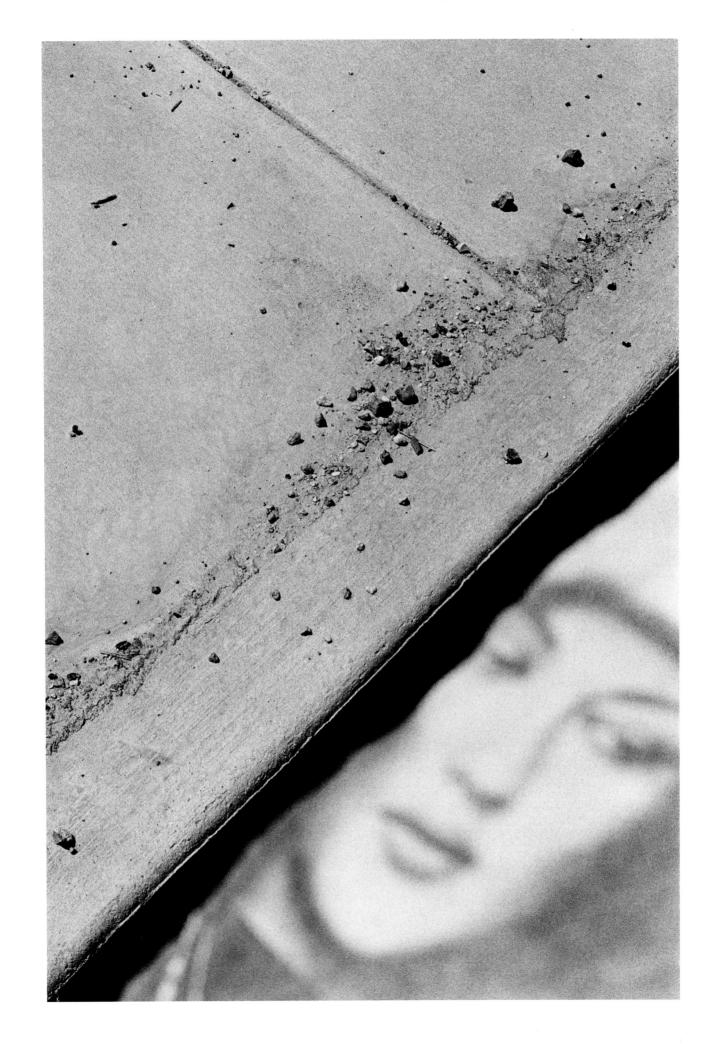

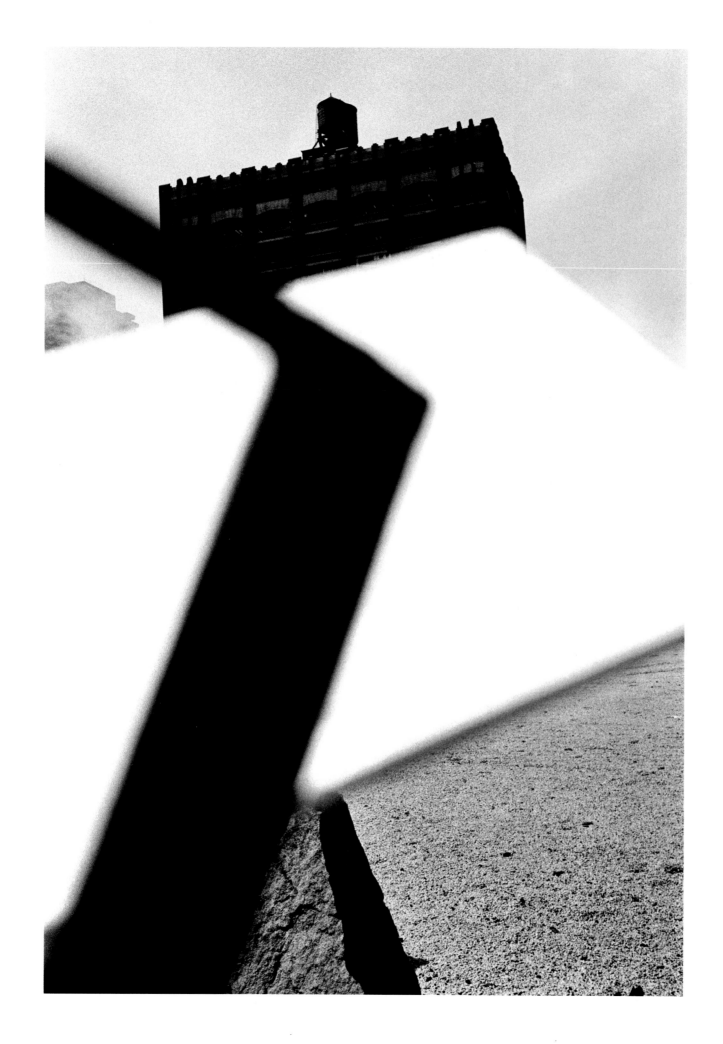

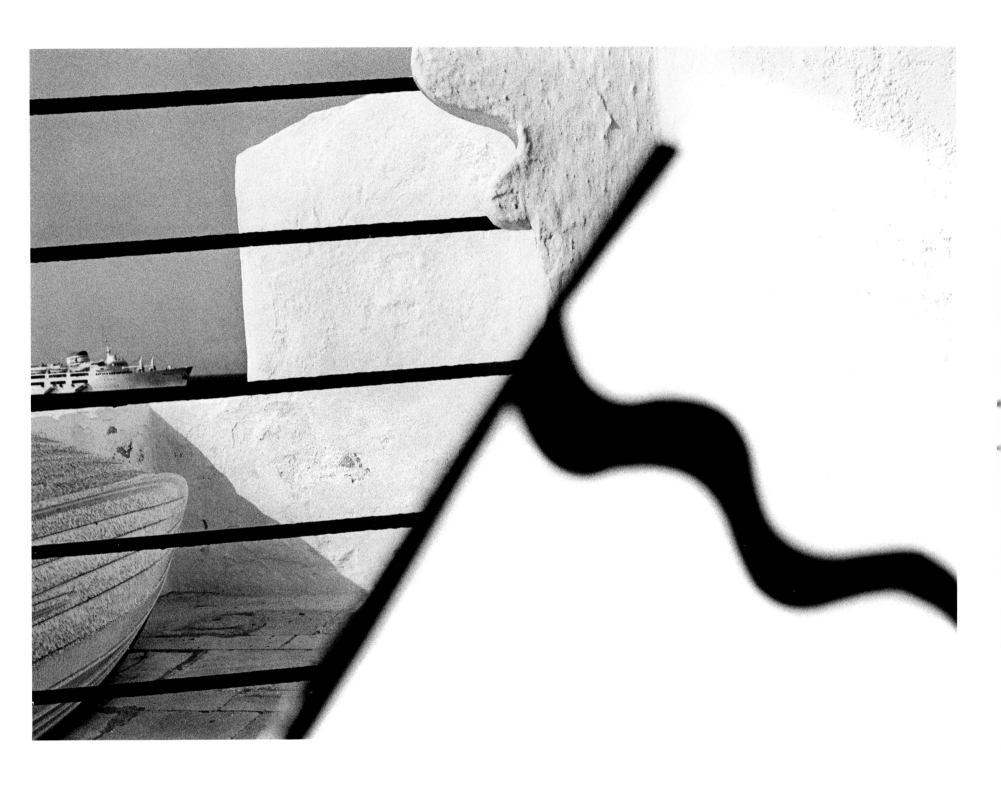

Pictus Interruptus: Mykonos, Greece, 1979
Pictus Interruptus: New York City, 1978 (left)

105

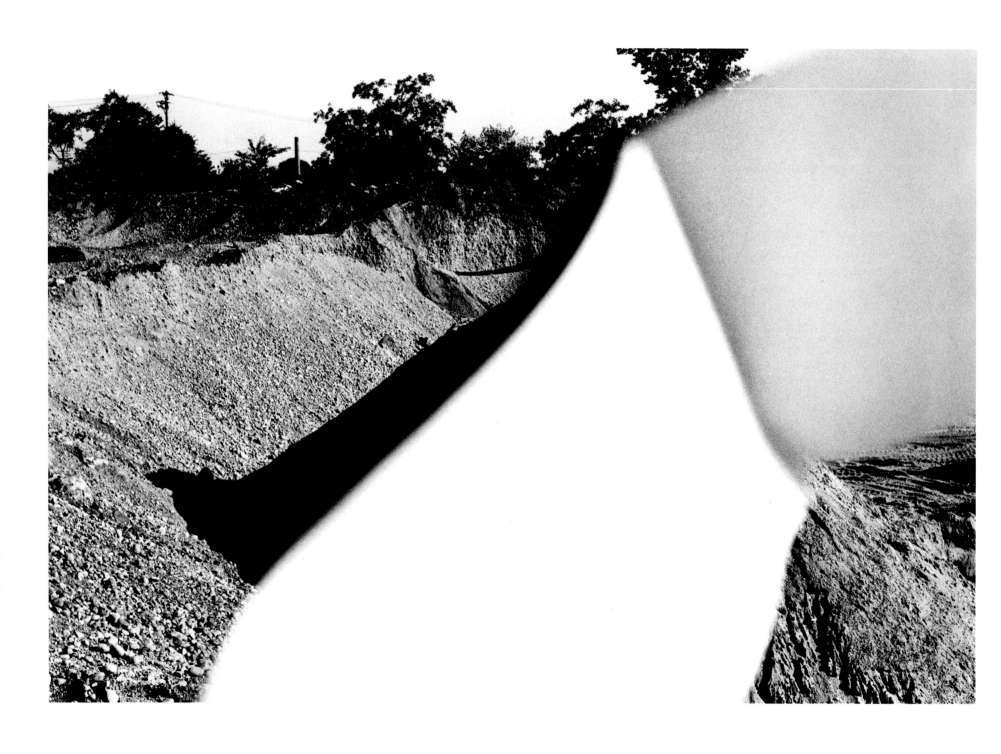

Pictus Interruptus: Beloit, Wisconsin, 1977
Pictus Interruptus: Camden, New Jersey, 1977 (right)

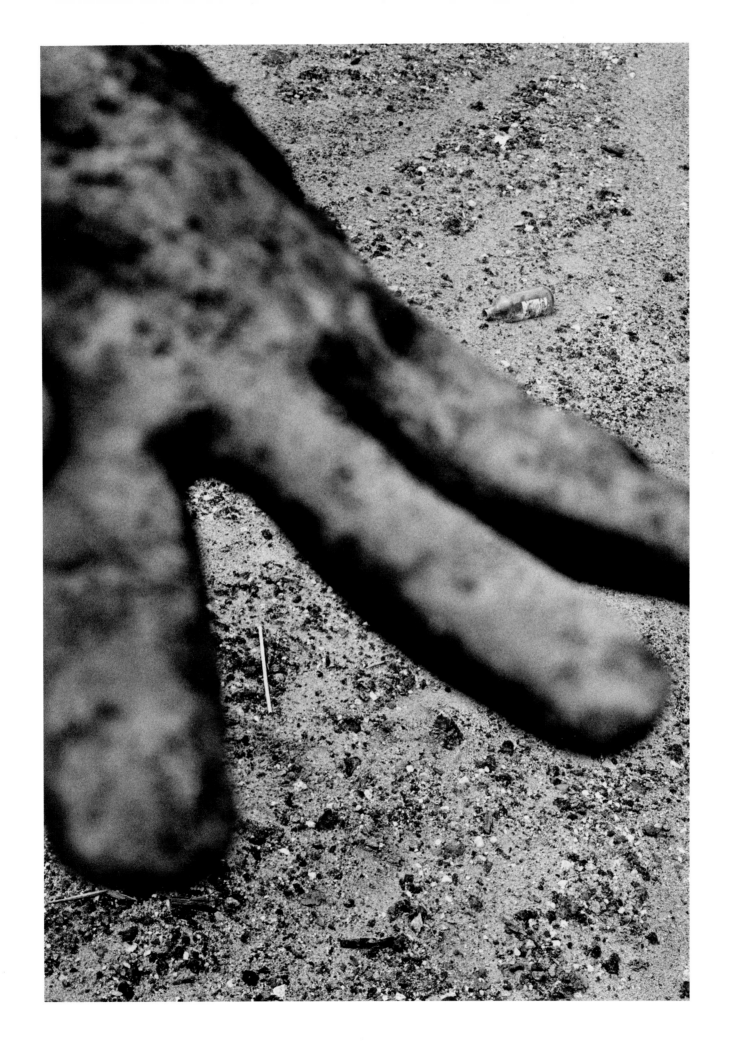

City Whispers 1980–1983

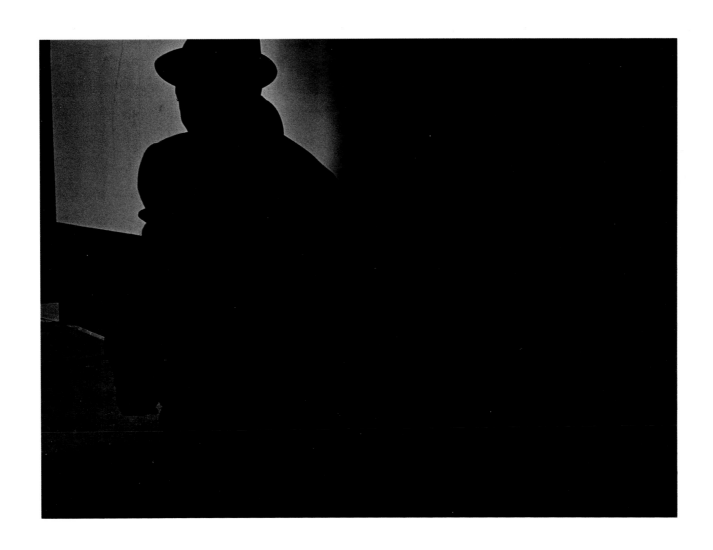

City Whispers: Glo Man Glo, 1980

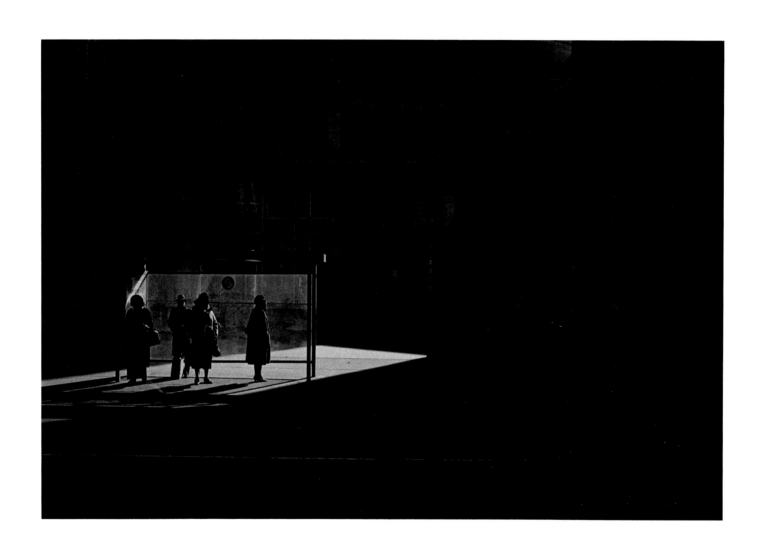

City Whispers: Philadelphia, 1981

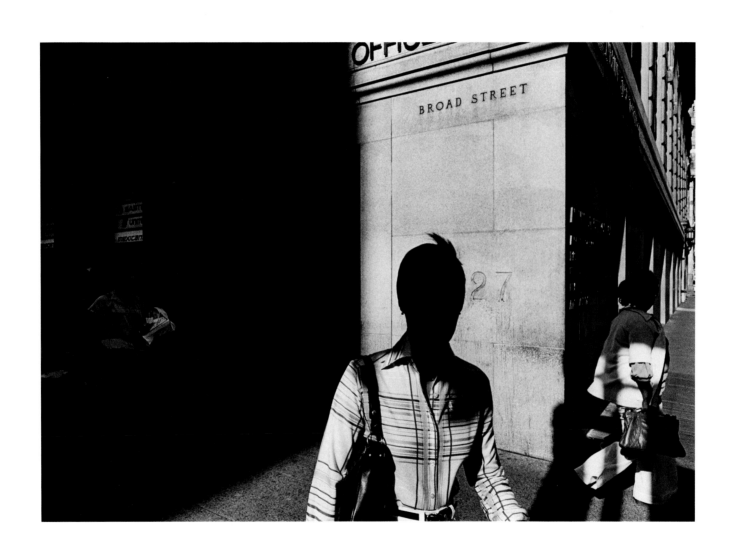

City Whispers: Philadelphia, 1980

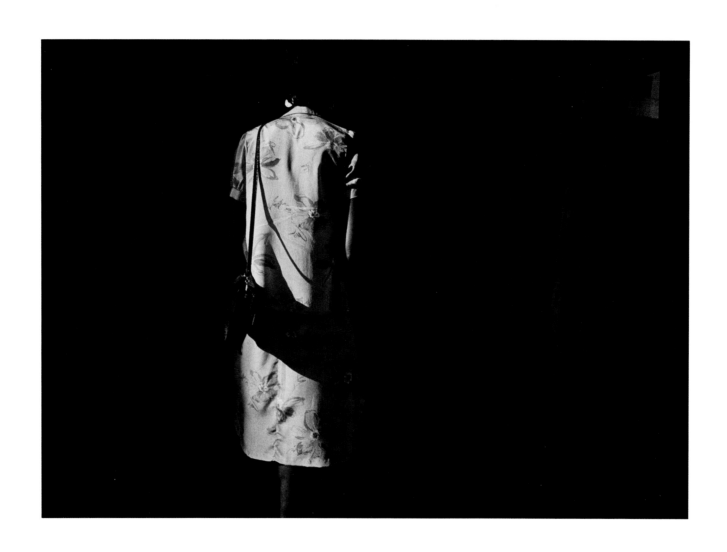

City Whispers: Philadelphia, 1981

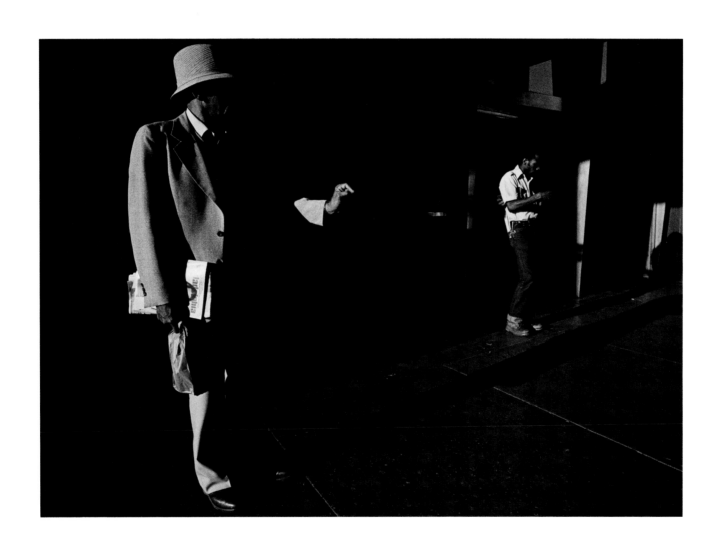

City Whispers: Philadelphia, 1981

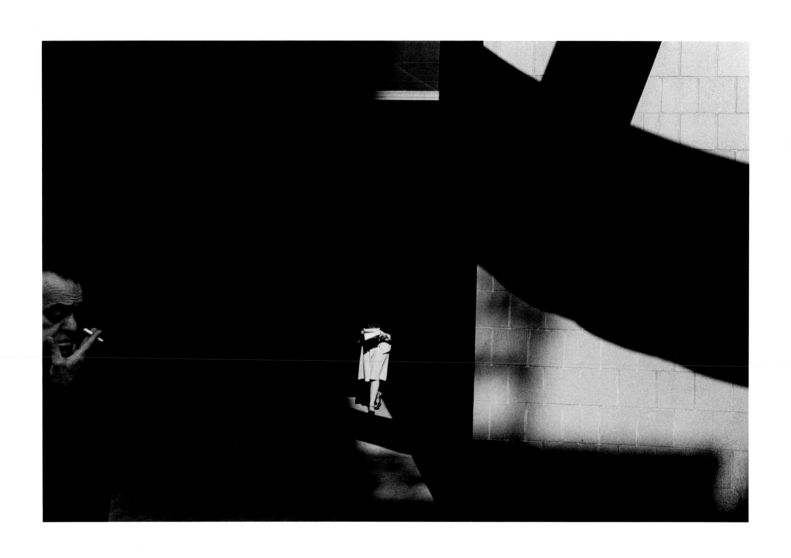

City Whispers: Philadelphia, 1982

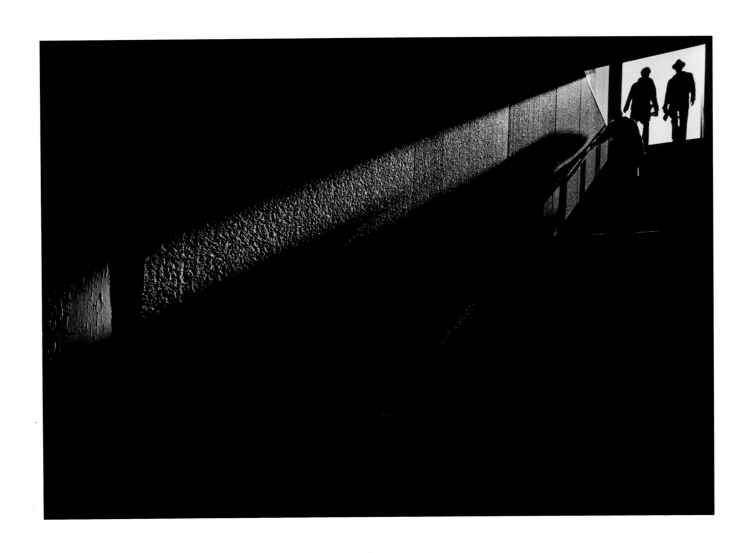

City Whispers: Chicago, 1981

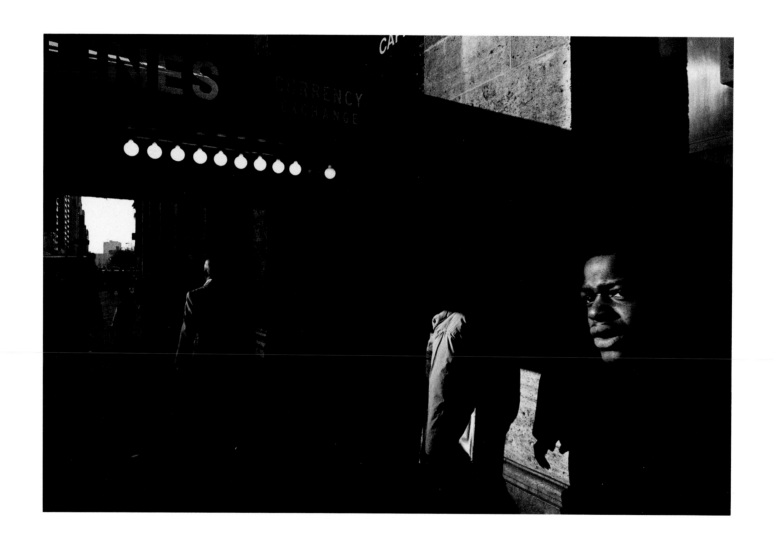

City Whispers: New York City, 1982

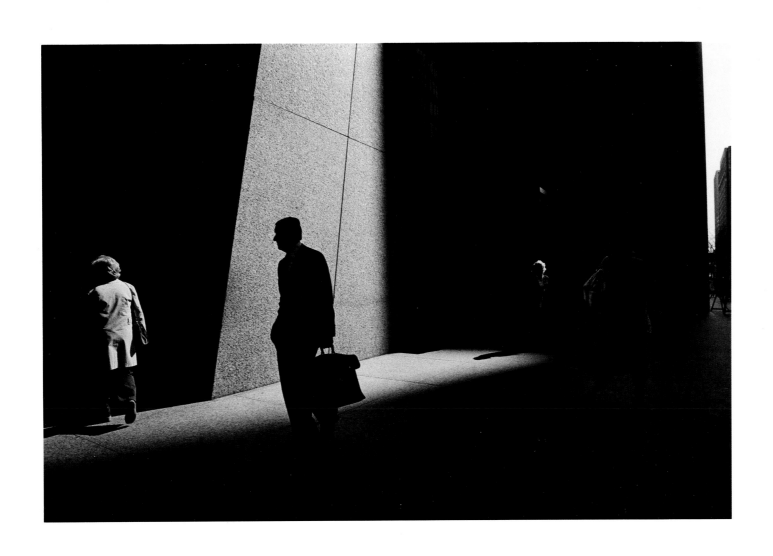

City Whispers: Chicago, 1982

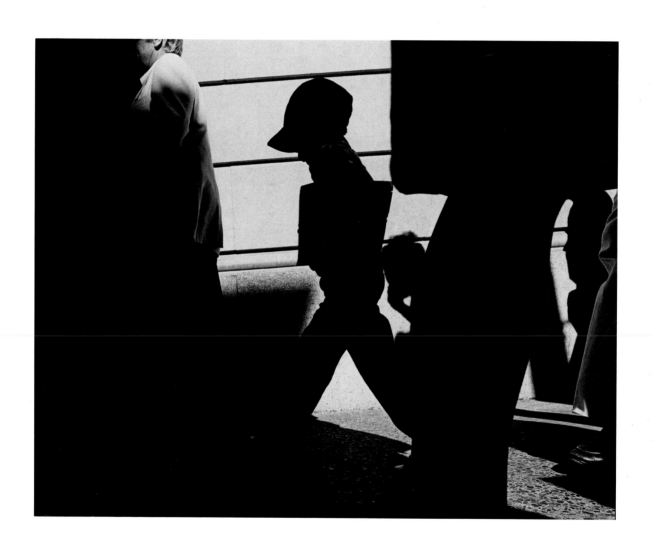

City Whispers: Philadelphia, 1981

Biography

All unattributed quotes are by Metzker. Numbers appearing in parentheses after each quote refer to sources as follows: (1) letter to Anne Tucker in the year in which entry is placed, (2) Ray K. Metzker journal, (3) Anne Tucker journal, entries from conversations with Metzker in 1983 unless otherwise noted, (4) The Selected Image, (5) notes by Metzker made on loose pages and kept in folders. For complete notations on reviewers' quotes, see Bibliography.

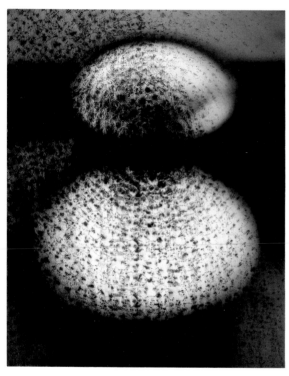

4×5, 1964

1931

September 10. Born in Milwaukee, youngest son of William Martin and Marion Krueger Metzker. Siblings: Mary Ellen (b. 1925) and Carl (b. 1927). Sister a victim of cerebral palsy; parents care for her at home. Family lives at 4930 Woodburn Street, Whitefish Bay, until 1949 (except for 1934–1939, when the Depression necessitates temporary move from suburb into Milwaukee).

"My parents were the children of a German community one step away from the boat. Before the Depression, they were gently shifting into the growing ranks of middle- and upper-class families." (3)

1944

Begins to photograph. Interest sparked by purchase of Kodak ABC developing kit. As postwar camera production resumes, buys Kodak Monitor folding camera which he subsequently trades for 2¼ × 3¼ Crown Graphic. Photographs for high school yearbook and newspaper and for the *Whitefish Bay Herald*, a weekly community newspaper.

"When I discovered photography, it was the ladder out. I have always taken a pleasure in working with my hands, so working in the darkroom and watching the prints develop was an additional new pleasure. Photography let me out; I had a mission." (3)

1949–1953

Attends Beloit College, Wisconsin; majors in art. Second semester of freshman year through junior year, photographs for the college public relations department. Particularly influenced by members of the art department: Clark Fitz-Gerald, art historian John Rembert, and chairman Frank Boggs.

Summers. Counselor and photography teacher at Camp Highland, Sayner, Wisconsin; camp director "Doc" Monilaw is a first model for teaching: "He drew me into that role."

Receives B.A. in art from Beloit.

1953

September through following March. Works as assistant in commercial and portrait photography at Robert Miller Studio in Cedarburg, Wisconsin.

December 8. Arthur Siegel lectures under the sponsorship of the Beloit Art League. Metzker takes notes which include: "Today it is the job of the photographer to see things in a fresh way. He must react to color and form, not reality."

1954

April. Drafted into U.S. Army; while stationed in Korea, from December 1954 to November 1955, serves as clerk in Education Office and teaches photography and music appreciation in Off-Duty Education Program. Visits Tokyo, Kyoto, and Osaka, Japan.

1956

January. Receives early release from military service to attend a post-graduate

semester at Beloit College; studies include nineteenth-century German drama.

Fall. Attends Institute of Design of the Illinois Institute of Technology through spring 1959. Studies under Harry Callahan and Aaron Siskind.

"There is a marriage, something of both Callahan and Siskind flowing in me. Over a period of time I came to recognize their authority. Their experience and dedication to quality was something you had to respect, and they communicated to me how really beautiful and of what great meaning a photograph or photographing could be. They made photography a noble endeavor; they drew one into the richness of the struggle. It is all that lies behind the photograph to which they gave insight.

"When I first went to Chicago, it was easier to deal with Harry; we were both midwesterners. We met periodically – one to one – and talked earnestly of many things. They were always thoughtful discussions, both stimulating and encouraging.

"I did not meet Aaron with the same ease. Unlike anybody I had known before, his New York mannerisms made him somewhat suspect. Our meetings were limited mostly to classroom, but I was drawn by his energy and the spirited encounters and looked forward to any opportunity to be in his company." (3)

1957

Meets Frederick Sommer, who teaches during the academic year 1957–1958 while Callahan is in France on a Graham Foundation Fellowship. Metzker shows his work to Sommer only once or twice.

"He was proposing such a radical system of work that involved working in the studio. I wanted to explore the world. I didn't want to get thrown by Sommer." (3)

"In the winter / spring of 1957–1958, I read Thomas Wolfe's Look Homeward Angel *and then* You Can't Go Home Again. *It was very potent for me. In* The Loop, *I shared with Wolfe trying to describe ... the multitude of events. He could see the drama everywhere, and that appealed to me. The* Loop *was a commitment to something large. I wanted something complex: night / day, people / building, traffic / silence. I wasn't interested in photographing my toes in forty different ways." (3)*

1959

Receives Master of Science in photography. Thesis: *My Camera and I in the Loop,* 119 photographs taken within Chicago's elevated transit that encircles downtown.

In his thesis statement, he writes:

"I worked for some time on the project believing that a quasi-objective study would result. This was replaced with the idea of a personal statement about the Loop. Eventually the concept of the Loop diminished...; my concern was for photographic form. The Loop was not so much the idea to be expressed as the situation or location wherein the camera and photographer find meaning. I wanted to photograph, and the Loop was the reason. If a statement of the Loop exists, it is of secondary importance to me. The primary value, realized only through working, is to have effected a productive relationship between the camera and myself."

Edward Steichen is asked and agrees to write a recommendation for Metzker's application for a Fulbright Fellowship. Steichen purchases ten photographs by Metzker for The Museum of Modern Art, New York, collection. Later in 1959, Steichen includes several prints in the exhibition *Photography in the Fine Arts I* at The Metropolitan Museum of Art, and in 1960 includes them in the exhibition *The Sense of Abstraction in Contemporary Photography* at The Museum of Modern Art.

June. After introduction by designer Massimo Vignelli, works through winter on assignment for Container Corporation. Makes photograph (page 37) of discarded paper rolls, which Metzker likens to a rose garden.

December 18–February 21, 1960. Exhibits seventy photographs from *My Camera and I in the Loop* at The Art Institute of Chicago; Massimo Vignelli designs exhibition brochure. Hugh Edwards, curator of photography at the Art Institute, purchases ten photographs from the exhibition and five prints from *Chicago* series for the institute collection.

Edwards writes in exhibition brochure, "The first attractions of these pictures are that they show us the Loop and suggest a new identification with our environment, but after we have looked at them again and again, it is the abstract pleasure of contemplation which remains as their final distinction."

Nathan Lyons includes Metzker work in group exhibition *Photography at Mid-Century* at The George Eastman House, Rochester, New York. Meets Paul Caponigro and Minor White at the opening. "That show was the first to recognize a community of young photographers," Metzker says. *(3)* Thereafter, Lyons includes Metzker's photographs in group exhibitions at The George Eastman House in 1961, 1963, 1965, 1966, and 1967.

1960

April (through December 1961). Travels by ship to Bremerhaven, Germany; takes delivery of a Volkswagen in Bremen. Two months into trip, cameras are stolen. Purchases two Leicas, a Valoy enlarger, and other printing equipment. Travels in Germany, France, Belgium, Holland, Switzerland, Spain, Portugal, Italy, Austria, Hungary, Yugoslavia, Denmark, Sweden, Norway, and England, with extended stays in Paris, Lisbon, Innsbruck, Malaga, and Frankfurt. In the latter three cities, sets up enlarger to make rough prints from negatives.

"My European trip, in terms of photography, was an unusual experience; I hope it remains unique. I would not wish to repeat the protracted accumulation of negatives. It has a sense of artificiality and confusion. In the case where the movement between camera and darkroom flows naturally, photography becomes much more exciting and thus rewarding. There are those who thrive with only a camera in their hands. I am of the opinion that the deeper meaning of photography can be found only in the completeness of the process." (5; 1962)

Meets Paul Strand at Strand's home in Orgeval, France. Strand responds favorably to portfolio of Metzker's photographs.

"Today was stimulating enough with the much-hoped-for meeting with Paul Strand finally happening. Strand had just returned from Spain when I first talked with him

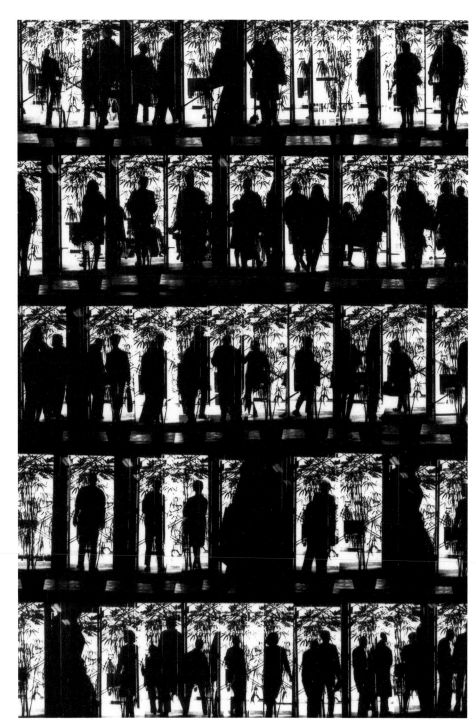

Composite: Philadelphia, 1965 (detail)

over the phone. Today he looked like a browned nut, sort of round or husky, but not fat. After a few minutes of verbal introductions, he began to look at my prints, and I should say he was fairly well pleased. He then began to talk quite freely, mentioning some of his early experiences with Steichen and Stieglitz. I saw Strand's books on New England, France, and Italy and original prints of beautiful quality." (5, 1962–1963)

1961
November to December. In Paris, during final two months of European trip, decides to seek a teaching position. Returns to United States.

1962
Lives with parents and sister in Mequon, a suburb outside Milwaukee. Prints negatives from Europe and sends applications to art and design schools to secure teaching position.

Spring. Sol Mednick, chairman of the photography department, invites Metzker to teach at Philadelphia College of Art (PCA). Metzker moves to Philadelphia for the fall semester and resides, through 1967, in the third-floor loft space at 1105 Walnut, within walking distance of the college.

"Philadelphia wasn't a very exciting city to come to — narrow streets, dull architecture (red brick, little stoops, unadorned doors and windows). Europe had so much romance, so much to look at. In 1962, the core of Philadelphia was rotting. South Street was a cesspool of poverty, and it repelled me. Center City was narrow and tight except for City Hall, and that's why I worked there. It was the most open space." (3)

1964
"In 1963 or 1964 I took a portfolio of thirty or forty photographs of Philadelphia to John Szarkowski at The Museum of Modern Art in New York. It was an unsettling conversation. I was looking for acceptance, and he offered resistance." (3)

Questions about the viability of single-frame photographs lead to *Multiple Exposure, Double Frame,* and *Composites* series.

"The first year in Philadelphia, I walked the streets with the 35mm camera, seeing the city and orienting myself. Then, feeling that I should expand, I took out the 4×5 view camera and, on the weekends when the streets were quiet, I made those pictures that deal with shadows on the wall. In teaching, I was stressing the experimental aspects of photography. One day, just before spring vacation, another faculty member came into my classroom after class, dismissed the experimental work on the walls, and proceeded to tell me what photographs should look like. I was cut to the quick and so angry that I decided not to travel during the vacation as I had planned but rather to push harder with the 4×5 ruminations in my studio. During the vacation I produced a series of prints, each made from one negative, but that negative had been exposed through another previously exposed and developed negative. So I always had a positive and negative image in each print. One [page 120] is a negative of two Campbell soup cans distorted by the camera until the circles become elliptical, then exposed through a negative of frosted glass. Another is a double negative of contact sheets in a developing tray; simple shapes can make highly evocative images. In these 4×5 photographs are the extremes of simplicity and complexity that recur in my work, but the 4×5s were a transition series, never a mature series. (3)

"At the end of the Christmas holidays in 1964, I was on a bus traveling from Milwaukee to Chicago when I started shooting with the idea of coupling adjacent frames. The results [page 61] were encouraging enough for me to continue with the idea in a series titled Double Frame *through much of the spring. By the end of 1965 I was pushing the idea of having one picture with two different vantage points." (3)*

1965

Works intensely on *Composites* series.

"Philadelphia, 1964 [page 66], was the first composite; it is made of forty-nine 2×2-inch prints which are made from two different 35mm negatives and printed for different densities. Philadelphia, 1965 [detail, page 122], came about when I discovered how I could use a window or door opening to locate a light source on the film. That opening and a backlit plant are constants in each exposure; variety is given by the figures entering and exiting and by the scaffolding which moves across the window during the succession of exposures. The roll of 35mm film was only partially advanced between exposures; thus there were three or four exposures in place of one, nearly a hundred on one roll, all made in twenty minutes. The camera's advance mechanism was marked so that I could note the exact relationship between the advance of the lever and of film. Philadelphia, 1967, was also made by overlapping 35mm exposures." (3)

"About the same time, I began thinking of the entire roll of film as one negative. Ten-inch sections of film were printed onto long strips of photographic paper and then mounted in rows, forming a final constructed piece which I called a composite. You can deal with the whole or you can deal with just one part. To me there is a richer experience if the two can operate together. What I am talking about is complexity. When you approach one of the large composites, you see it more as an abstract design, and when you come in closer, you see a wealth of everyday information. There is no particular point of entry or procedure to the seeing; it is a multiplicity of elements operating in an aleatory manner." (4)

"Simultaneity was a key factor – ongoing, continuous interaction of one element or form with another. My need was to integrate the variety of experience, to fashion a form that pulled diverse parts together without stripping the parts of their vitality." (2; 1977)

"At this time I was reaching into music and into flux. I was working with kinetic sculpture, building toys that would flip-flop. I didn't have the expertise for these because they needed to be electrical. So I said to myself, I know photography. Why can't I take these ideas and bring them back into photography? Percussion, the playing of one beat against the next, began to translate into the photographs." (3)

"The size of the largest composite was 35½ inches high because ten inches of 35mm film in my 8×10-inch enlarger would project to 35½ inches when the enlarger head was touching the ceiling." (3)

1966

January. Purchases building at 733 South 6th Street, built in 1851 to house the Hope Fire Company.

April. Receives John Simon Guggenheim Memorial Foundation Fellowship for experimental studies in black-and-white photography. In grant application, he proposes to indicate "the potential of the black-and-white still photograph to deal with complexity of succession and simultaneity.

"For some time, I have found myself discontented with the single, fixed-frame image, the isolated moment that seemingly is the dominant concern of still photography today. Instead, my work has moved into something of the composite, of collected and related moments, employing methods of combination, repetition, and superimposition as I find the opportunity in the camera, the darkroom, and the final presentation. Where photography has been primarily a process of selection and extraction, I wish to investigate the possibilities of synthesis."

Because of Guggenheim Fellowship, postpones remodeling South 6th Street residence until spring of 1967. Continues work on *Composites* series.

1967

April. Contractor begins major renovations on South 6th Street residence. Metzker moves in June; renovation continues weekends and summers until 1970.

Spring. With Robert Heinecken, Jerry Uelsmann, John Wood, Donald Blumberg, and Charles Gill, is included in exhibition *The Persistence of Vision* at The George Eastman House in Rochester, New York. Five *Composites* and five *Double Frames* published in catalogue.

Acquires a half-frame camera and begins to photograph series titled *Couplets* at beaches at Atlantic City and other New Jersey shore towns.

"With Composites, *the working procedure was that they were all variations on one location. They represented the prolonged or extended moment. I wanted the* Couplets *to be discrete moments, discrete to the point that visually they did not have overlapping forms. The viewer put it together. Without the viewer's inference, the* Couplets *don't make sense versus the composites, which gained unity through more obvious visual devices. The images in* Double Frame *had to be contiguous, and in early* Couplets *I adhered to that. Then I realized that since the black frame, not the center line, was the key or the 'term,' I was free to join the prints in the darkroom rather than in the camera." (3)*

"A recurring theme, perhaps less obvious and certainly less conscious on my part, is that of generational change: a reference to time, position and stages in life. The man and the baby [page 76] are linked by a common gesture, as if they were one and the same, only separated by sixty years. It is a kind of speculation; how was the man as a child, and how will the child be as a man? A gesture and question couple two remote images. The old man was photographed in New York and the child at Atlantic City, but for my sensibility, the two belonged together." (4)

October 25–January 31. Twelve *Composites* exhibited in one-man show at The Museum of Modern Art, New York. Harvey Zucker declares the works to be "the most accomplished use of multiple imagery in creative photography to be found anywhere." Critic Emily Wasserman recognizes that *Composites* "seem to be tentative experiments toward the definition of a radically new pictorial form and structure" but concludes that "content per se is not at all of importance, giving way as it does to the graphic impact of the whole. At its worst, this transformation of subject into pattern becomes a decorative surface 'look,' substituting a chic artiness for real depth and interest." Minor White concurred: "At a distance the result is an optical texture, more or less intriguing but always without content."

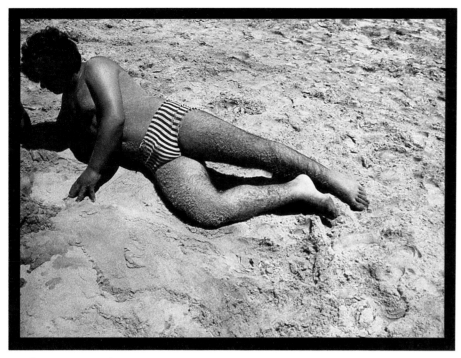

Sand Creatures: Atlantic City, 1975

1968

Spring. Participates in major symposium at The George Eastman House which coincides with the exhibition *Vision and Expression*; other lecturers are Jerry Uelsmann, Paul Caponigro, and Garry Winogrand.

"This was one of the first efforts to bring students together for them to meet and to see a survey of photographs by contemporary photographers." (3)

Summer. Proceeds with photographs at New Jersey shore for the series later titled *Sand Creatures*; continues each summer through 1977.

"These pictures speak to, and about, humanity.... What I see is not sweet, nor is it harsh. Perhaps it is more a tenderness. I want the content to speak for itself, and that calls for a bit of self-effacement. Exploiting the ridiculous or the absurd would be too easy, too detached, and too negative.

"The beach is a place where people reveal themselves. One is exposed to an intimacy that is usually restricted to more private situations. I viewed it as something strange and wonderous. If I felt otherwise, I could not then approach the subject." (4)

"Society doesn't appreciate the lumpen menschen. The lumpen figures communicate so directly; you don't have to go outside of the picture for connotations. In other pictures, the associative aspect is rich, but it depends on the sophistication of the audience. The danger with associations is that the references are too obscure. But Sand Creatures *are not without associations.* Atlantic City, *1971 [page 82], feels like a Pompeiian figure, fleeing, pushing into the soil.* Atlantic City, *1975 [page 124], is paradoxical. He is cherubic, but when you look closely, the figure is more that of South Philly meat. He is a tough guy.*

"When it comes down to it, I am really obsessed with passive figures, fleshy, puffy bodies and limbs that z'ist at the elbows and ankles. When I backed away from the figures, the lens flattened them out and they became distant floating figures. With more proximity, the figures gained more dimension. The flesh had quality. Having the frame cut the figures avoided excessive ordering and also conveyed the glimpses with which we naturally view life. It is random...pop, pop, pop.

"I am willing to have humor, but not to be cruel. They are gentle, vulnerable, fragile bodies. They are not glamorous.

"These creatures are my family." (3)

1969

Eugene Ostroff, curator, National Museum of American History, Smithsonian Institution, purchases two small *Composites* and ten other photographs for the Smithsonian Institution collection.

"Support from the outside – purchases, grants – was of unquestionable value when I was getting no recognition from the administration or colleagues at PCA." (3)

1970

April 10. *Life* magazine publishes *Philadelphia* 1967, from *Composites* as double-page spread in "Gallery" section.

Spring. Sol Mednick dies; Metzker regards changes in focus of photography department at PCA as negative, accepts job offer from Van Deren Coke at University of New Mexico, Albuquerque.

Fall (through spring 1972). Becomes a visiting associate professor at the University of New Mexico.

"I was actively seeking a change and wanted some place other than another urban center. I also accepted the job to break the routine of working on my house. I was getting perfectionist about it, which would ultimately be unproductive." (3)

"Albuquerque was not only change but shock. So much was different that it was not possible to continue with multiples. Unknowns, mainly the scene and the light, created a need to reacclimate. I turned to the print, diminishing the role of the nominal subject." (5; 1980)

"In trying to get a clean outline on everything, I began to delete details, even whole objects. For example, I removed a window from a white wall [page 99] and in another photograph masked the bushes. Some New Mexico pictures seem very architectonic, and yet none of them are really hard, because there is always an attempt at featheriness, either in the bushes or clouds. This introduces a little playfulness or softness." (3)

New Mexico work calls for change in print size.

"I made a decisive switch to 11×14-inch paper. All my previous work had been geared to printing on 8×10. Previous attempts to print in a larger size were not successful. If I wanted 11×14-inch prints, I knew I had to make negatives that would work at that size." (3)

Begins two series, *Whimsies* and *Wispies*. Small composites in diamond configuration. *Whimsies* contain four 2½-inch prints of plant forms photographed in New Mexico. *Wispies* contain sixteen 1¾-inch prints from Kodalith negatives of newspaper type. Series continue through 1974.

The Milwaukee Art Center mounts 117-piece Metzker exhibition as the third segment of a three-part series titled *Bennett, Steichen, Metzker: The Wisconsin Heritage in Photography*. The three exhibitions open simultaneously. Metzker and Bennett segments each accompanied by a catalogue and subsequently tour U.S.

John Szarkowski includes works in *New Photography, USA*, a circulating group exhibition organized by The Museum of Modern Art; two identical versions of the exhibition travel in Europe, Japan, and South America. The museum purchases three *Composites*.

1971
Milwaukee Art Center exhibition travels to the University of New Mexico Art Museum, Albuquerque.

1972
Fall. Returns to faculty position at Philadelphia College of Art.

Milwaukee Art Center exhibition travels to the Wright Art Center, Beloit College, Wisconsin.

1973
Begins period of darkroom experimentation.

"Solarization, Dark Probes, and Philadelphia Flashed all aim at transformation, at distancing themselves from straight, evenly balanced traditional systems of printing. I am not interested in transformation just for effect but in the feeling of the line and in the edge and how you resolve it. It is a concern that goes all the way back to the Institute of Design and then really came forward when I was working in New Mexico.

"Solarization creates real ambiguity in that it contracts and flattens space radically. It puts a lot of emphasis on the glowing line in flattened space, and heightens the sense of movement in the line. Often, people who solarize use their regular negatives which carry too much information for a successful transformation. The intent is to find something very simple and mundane and let the process transform it into something monumental. Solarization needs a mundane negative to sing [page 126]. It is the Stonehenge syndrome. Stonehenge is just rocks, but....

"The prints in Philadelphia Flashed were flashed before development. Those for Dark Probes are underexposed and overdeveloped. I began flashing pictures after I returned from Albuquerque, where the strong light gave the pictures so much contrast; they were super-jumpy. My reaction was to soften. Flashing pictures made the blacks carry the weight because the white had been muted.

"Also, in New Mexico, there was the edge of the bush or the outline of the stick versus the architectural line of a wall or a door. These lines played back and forth. Dark Probes moves away from intense black / white and cookie-cutter shapes balanced in a frame. I wanted to work with the subtleties of a black field and with grain.

"I learned to really appreciate grain activity when I moved up to the 11×14-inch paper: sharp, big, globular grain. What I learned was how to build out a field of grain. The grain took precedence over rendering by the camera.

"Solarization was laid aside again by my work on Pictus. Once again I was pulled between what is fabricated and what is distilled from the street. I will return to solarization; it has so much potential. I feel that I am at the edge of it and don't get the sense of repetition or exhaustion as I do for instance with the reclining figures in the Sand Creatures series." (3)

1974
Receives National Endowment for the Arts Photography Fellowship but postpones taking time off from teaching until following spring because of illness and subsequent death of Barbara Blondeau, friend and chairman of photography department at Philadelphia College of Art.

One-man exhibition of *New Mexico* series at Dayton College of Art, Ohio.

One-man exhibition of *New Mexico* series at The Print Club of Philadelphia.

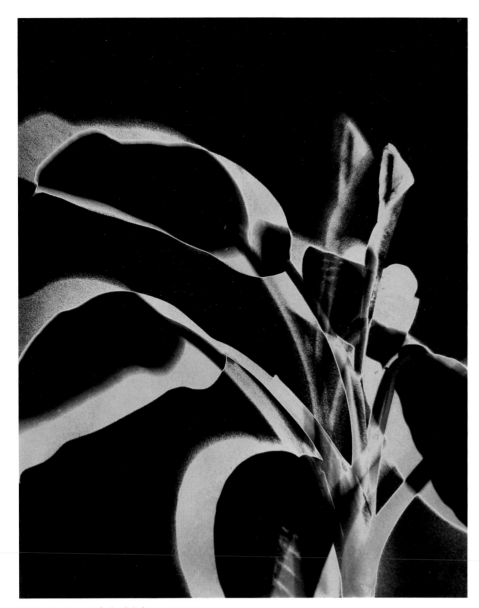

Solarization: Philadelphia, 1973

1975
Uses NEA fellowship period to print *Sand Creatures*. Begins *Philadelphia Flashed*.

1976
Travels to Switzerland to attend opening of one-man exhibition at The Picture Gallery, Zurich.

Restores the 1851 façade of 733 South 6th Street residence.

September through November, Metzker gives himself a sabbatical in Paros, Greece. (During this and subsequent visits to Paros, stays in house of Laurence Bach, a photographer and former student, and his wife, Penny.)

"When you are younger, you are healthy but blind. You believe that everything is going to work. You think that you and the world are a match. As you get older, it no longer seems that way. Between 45 and 50, you have to reconsider and to ask if this is what you wanted your life to be." (3)

"I had attempted to deal with the problem of balancing the dual demands of personal work and teaching by requesting reduced teaching loads. However, as that was not enough, I went one step further and requested a leave of absence in 1976. I felt the need to remove myself from the web of routine, which has a way of forming around us. I wanted change. I wanted contrast — something to resensitize the seeing process. My needs were satisfied on a Greek island. Paros offered quietude, a constancy of light and — of no little importance to me — a darkroom. I had ideal conditions where I could work free of distractions.

"The decision to take that leave of absence has an importance in my mind equal to the one of going to graduate school or the one that let me wander in Europe for 20 months. A door was opened. My work encountered a significant development. In those three months on Paros, the seeds germinated for the series titled Pictus Interruptus. *If I hadn't taken my own sabbatical in 1976, I wouldn't have asked for the second Guggenheim in 1979." (3 and 5)*

"Greece is a charmed affair, one of inexhaustible surprises. Life appears simple, daily routines are performed in narrow limits. The elements are known — sea, sky, land — nothing added or subtracted but subject to constant change. The result puts me in awe. The elements exist on a grand scale. Sky and water are vast. It is possible to be overwhelmed, yet small delights tease me into responding: the water lapping at the shore, light illuminating a nook. The magic of the land is that impetus to respond, which might be called inspiration." (2; 1979)

"Despite the tranquility, the time will pass rapidly. The days are filled with excitement. I barely finish breakfast before something catches my eye. I pick up my camera and I am gone. Planning is a disaster. Yesterday, I intended to return to the park in town. I knew that I should be there by 5:45 or 6:00 pm. Although I left the house in good time, one shot...another...after another...and I arrived at my destination as the sun oozed its last, about 7:15. If that is but one example, then you have some idea of how my life is on Paros.

"As long as the weather remains so favorable, I will stay here and work. It is just too good an opportunity to dissipate with a lot of sight-seeing. My problem is keeping up with the processing. Film is easily developed. Printing, on the other hand, has its

discomforts. Contacts (all that I'm going for) are made with a flashlight. Fortunately, there is RC paper which gets washed at the well and hung on the clothesline. I smile at the thought of students at PCA grousing over certain little shortcomings in the school's darkrooms." (1)

"The eye is completely overwhelmed in the beginning. Enthusiasm is general. But soon the eye fastens on the particular, without too much apparent meaning – no time to panic, for something is brewing. What I am concerned with is an alternative to the Greek definition of beauty. Greece offers 'beautiful' pictures with its shimmering water, sunsets, white walls, fishermen, boats, and ruins, but that seems too simple – really dull. Photography is filled with ready-mades, shoot by the numbers, just follow the quickie books. Certain subjects are too readily acceptable to photography: nature, people, industry.

"It becomes clearer as I work here on Paros, where nature and the landscape dominate, that I am looking for that unknown which in fact disturbs, is foreign in subject but hauntingly right for the picture, the workings that seem inexplicable, at the very least, a surprise. It is man's imprint that I want to combine and contrast with nature.

"What really concerns me is some kind of crossover: natural / unnatural. Just taking a piece of writing paper out-of-doors, inserting it in the frame, bringing it to the edges of nature, and watching the two meet has a kind of excitement for me. All of a sudden wind becomes the important agent, the maker of situations, the giver of form.

"A piece of paper, so plain, so unassuming, so full of potential, to be marked, torn, cut, folded. A piece of paper in nature's field, an interloper, a weather vane, a foil, a cover, a projection screen." (2; 1976–1979)

Spends three weeks in Egypt before returning to United States in mid-December; continues *Pictus Interruptus* series.

1977

January 22. Speaks in panel discussion, "Students of Harry Callahan," with Emmett Gowin and Arthur Sinsabaugh, at The Museum of Modern Art.

Spring. Visiting adjunct professor, Rhode Island School of Design, Providence. While in Providence, stays with Aaron Siskind.

"Joe Jachna, Ken Josephson, and I have all worked with interrupters. I saw Jachna's mirror series in 1973. That's all I saw of his work until I came back from Greece and was living with Aaron while I taught at Rhode Island School of Design. One day a poster came from Jachna with a picture made in Colorado with a triangle in front of clouds. I knew immediately what he was doing. While I was in Greece working on Pictus, I had also thought of Josephson's things placed in front of the camera.

"There is an overlap with other photographers, but there is also my own lineage. The Pictus *series integrates and distills my work from 1972 to 1976. The idea of constructing something for the camera had been on my mind, especially while we were restoring my house. I looked at the bits and pieces of wood lying around. There was something intriguing in those loose pieces, so while I was in Greece, I remembered these shapes and fabricated them to use. But the idea of* Pictus *goes even further back to the white walls in New Mexico."* (3)

"Pictus Interruptus is a photographic experience on another level. The usual emphasis on subject matter is displaced. There is greater plasticity to the working of the visual elements. I find myself disposed to taking liberties with the space in front of the camera. I have moved from the attitude of observer to one of the intruder." (5; 1979)

"I asked myself why objects which were most important and closest to the camera were always in focus. It is the same with our perceptions. If I focus on an object with my eyes, I have a detailed perception – sharp and centered. But in Pictus *I invert the normal order. The object is close, so it holds my attention, but it is out of focus, so it also pushes me away."* (3)

1978

June (through spring 1979). Becomes chairman of photography department, Philadelphia College of Art; duties leave little time to photograph.

April 11–May 7. Included in *Spaces* exhibition curated by Aaron Siskind with a catalogue by Diana L. Johnson for the Museum of Art, Rhode Island School of Design. In the catalogue, Siskind speaks of Metzker's significance, especially regarding *Double Frame*. "His step from a simple picture to two frames combined into one was at the time a very major advance, and I don't know whether he was the first one – probably not – but to make the step and to have done it in the variety of ways in which he did it – turning the camera, combining a vertical and a horizontal.... They all sound very simple now, but they weren't, and, of course, the important thing is not only that he did it, but that he made very beautiful pictures."

April 17–May 9. One-man exhibition of *Pictus Interruptus* at Marian Locks Gallery, Philadelphia. Janet Kardon, *Art in America*: "The textures of grass, gravel, or pavement become like the textures of papers in Cubist collage – signals of the real world, emerging from an abstract context. Thus Metzker intensifies our sense of reality and abstraction at once; his disassociative process is a highly constructive one – responsible handing of a difficult idea."

July 28–October 2. John Szarkowski includes *Composites* in *Mirrors and Windows: American Photography Since 1960*, exhibition at The Museum of Modern Art; exhibition travels to seven other American museums.

September 16–November 5. *Ray K. Metzker: Multiple Concerns*, eighty-eight-print retrospective organized by William Ewing at the International Center of Photography in New York; modified version of exhibition tours. Owen Edwards writes in *American Photographer*: "Metzker is a seeker after pattern in the outside world, not design created afterward in the alchemic environs of the darkroom. He sees interconnections and unsuspected collaborations everywhere, and with a steely, scientific discipline he proves to us that they are really there.... For more than twenty years he has pursued the patterns of oblique interrelationships with a steady instinct and an increasingly agile inventiveness."

Peter C. Bunnell writes in *The Print Collector's Newsletter*: "Metzker's fundamental interest was to isolate the unique formal aspects of the medium and to see if they could embody an expressive statement – a statement rather far removed from the psychological humanism of much of the work surrounding him. All of Metzker's work since has been a continuous step-by-step articulation of

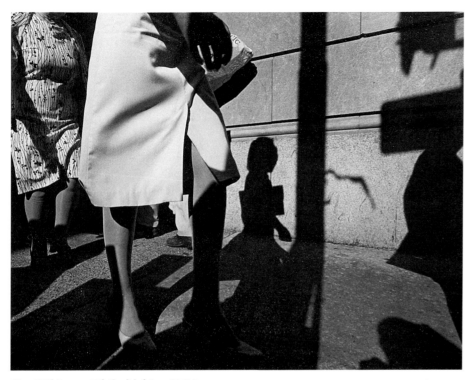

City Whispers: Philadelphia, 1981

this desire. It has been a challenging of himself to make the picture be of something and simultaneously exist independently as a photograph. This sense of objecthood is the key to understanding the best work in painting since Johns and Stella, and it is the same for the photography of Metzker and others like him."

1979

Signs three-year contract with Light Gallery, New York; solo exhibition at Light in 1979 and each subsquent year; March 7–31, shows works from *Pictus Interruptus*. Vicki Goldberg, *Cue Reviews*: "Ray Metzker's highly intelligent pictures explore the nature of the photographic enterprise and snare the mind but rarely the heart."

Receives second John Simon Guggenheim Memorial Foundation Fellowship to continue work on *Pictus*.

"The Just-Say-Go confirming letter arrived today from the Guggenheim Foundation. Elated! Got to get far from committees; they are pits of torture and insanity. Antidote is Mediterranean water." (1)

"It is a great and wonderful experience to know that one is free to work each day, that nothing cries for greater attention. Work is my fond distraction." (2)

Summer. Anne Tucker includes Metzker in *Contemporary American Photographers: Curator's Choice*, one of twenty-five exhibitions at *Venezia '79: La Fotografia*. In September, Metzker travels through Italy to Greece.

"Paros is another world. Devoid of stress, a very intense, productive experience. Even reading is a distraction. I spend my mornings at my desk making interrupters for the Interruptus *series, the afternoons until dusk photographing, the evenings after dinner, developing film. These are very fine months of focus. I can laugh that 'no interruptions' has allowed me to make the* Interruptus *series." (3)*

"While working in Greece, I had two pieces of music in mind: Rachmaninoff's Suite #1 *and the Von Karajan recording of Tomaso Albinoni's* Adagio in G. *Rachmaninoff is water / light / atmosphere. Albinoni is a cathedral, mass and shadows." (3; 1980)*

Fall. Modified version of International Center for Photography exhibition shown at Galerie Delpire, Paris.

Sand Creatures is published by Aperture. Critic Kelly Wise, *New England Journal of Photography*: "Although a number of the images include the sea, the essential subject of this book is not sea but the beach and its inhabitants, who are drawn there in a kind of tribal worship. Theirs is a ritual of trust and innocence, blessed by wind sun and sand.... I like the affections he discovers and shares. I like the way bodies at his beach sidle near each other (and sometimes touch) in the hot, warm, or cooling sand: I have always liked silent caresses."

November. His father, William Metzker, dies.

"He and my mother had been married for fifty-five years and had remained healthy. Six months before his death, they entered a nursing home." (3)

Mother dies in April 1982 and sister in August 1983.

1980

January. Modified version of retrospective from the International Center of Photography shown at The Chicago Center for Contemporary Photography, Columbia College.

One of ten Pennsylvania artists to receive Hazlett Memorial Award; exhibition of award recipients at William Penn Memorial Museum in Harrisburg, Pennsylvania.

"To find myself singled out for this award leaves me in the rather uncomfortable position of not knowing what to say. For the governor to show his support for the arts is, of course, a significant gesture. But there is discomfort in being the subject of a media event, because it seems to emphasize the personality rather than the accomplishment. The accomplishment, of course, is dubious or debatable. The goal resides in striving for sense; a media event is the opposite of that end.

"I am accustomed to being the observer, not the subject." (2; 1980)

January. Solo exhibition of *Sand Creatures* at Pennsylvania Academy of Fine Arts.

January 31–February 23. Small exhibition of photographs from *Sand Creatures* at Light Gallery, New York.

Spring. Begins *City Whispers* series as the result of an urge "to go back on the streets, an urge that came with the Guggenheim after I had returned from Greece."

"My new work has a different sense of space. The people are boxed by glass, by light, but the image itself is not perpendicular to the frame. It is not shot frontally. The diagonal recedes and implies a continuum. I am reaching into the shadows where the shadows become alive. I want the thing to be small, rich, and very intense. I am trying to eliminate more, yet have that which remains sing.

"I don't photograph ultra-fancy people. I don't go for that knockout woman in her prime, because I think haute couture is so much effort for so little return. I prefer to photograph the lumpen menschen.

"I am interested in everyman, less the specific individual. One of the best ways that can be shown is to silhouette the figure. In one roll of film, numbered 81 HK, in City Whispers, I was attracted to that wall which is at 17th and Walnut in Philadelphia. The light was right, creating strong shadows. I kept going back to photograph there, but when I got in the darkroom to proof, the pictures were not charged enough. I wasn't letting the shadow and the people overlap. I needed the fragments to collide. So I went back and changed my position to a lower one [page 128]. The first pictures at the wall had been too clean, not the churning activity of the street, but the contact sheet of the HK roll was exciting." (3)

Fall. Visiting adjunct professor, Columbia College, Chicago. Appointment renewed for the fall semesters, 1981 and 1982.

December. Resigns from faculty of Philadelphia College of Art.

"On a cold, cold December 10, I did drop my letter of resignation to PCA in the mailbox at the corner." (1)

1981

February–March. Solo exhibition of *New Mexico* and *Pictus Interruptus* at Paul Cava Gallery, Philadelphia.

Paula Marincola, *Afterimage*: "The best of the work in this exhibition has been rescued from the pedantic and repetitive, not only by sheer compositional beauty and prodigious technical skill but by the passion of Metzker's conviction as he has pursued his investigations. This ardor is palpably conveyed in imagery that is at once sensuous and cerebral. Metzker continues to expand the expressive potential of photographic formalism."

April 30–May 30. One-man exhibition of *Pictus* at Light Gallery. Andy Grundberg, *Modern Photography*: "It goes without saying that Ray K. Metzker is not a photographer whose main goal is to explain man to his fellow man. If we scan his work for easy ideological or emotional morals, we are little rewarded. However, if we accept the notion that the pursuit of visual logic can have a logic and beauty of its own, as expressive as those modes of photography directly devoted to expressive aims, then the magnitude of Metzker's achievement to date becomes clear."

Spends two weeks as visiting artist at Southern Illinois University, Carbondale.

1982

November 7–12. Invited by Aperture, a division of the Silver Mountain Foundation, to attend conference of eighteen photographers, poets, performance and graphic artists, editors, critics, and curators at Esalen Institute in Big Sur, California. Proceedings of the conference published in *Aperture*, no. 93.

1983

Terminates teaching contract with Columbia College; first year in twenty without teaching responsibilities, excluding leaves of absence.

January 5–February 4. Included by Harry Callahan in exhibition, *Harry Callahan and His Students: A Study in Influence*, at Georgia State University Art Gallery, Atlanta.

March 1–26. One-man exhibition of *City Whispers* at Marian Locks Gallery, Philadelphia. Victoria Donohoe, *Philadelphia Inquirer*: "The Ray K. Metzker exhibit... reminds us how this artist abhors the neutrality that so many American photographers have allowed to overwhelm the vitality of their work."

May. Travels to Paros, Greece, for the third time.

September 6–October 11. *Twenty-Five Years* at G.H. Dalsheimer Gallery,

Baltimore. John Dorsey, *Baltimore Sun*: "Metzker subjugates and even annihilates subject matter in the perfection of an aesthetic.... He uses people, not for their own sake, but as pattern, as composition, as elements in an aesthetic statement." Barbara Young, *Baltimore Sun*: "Mr. Metzker's sense of design is extraordinary, breathtakingly clean, pleasing to the eye. To me, many of his photographs speak to the existential anxiety which each of us has felt on those rare moments when we have dared to imagine ourselves a bright speck in the midst of a huge dark universe, a silhouetted individual lighted for our moment in the endless expanse of time.... Metzker uses his people to express the reality of universal human experience."

Serves as juror for All-Army Photo Contest; judging at SHAPE Headquarters, Mons, Belgium. Spends remainder of two weeks in Germany with a week in Berlin.

November 18–December 10. One-man survey exhibition at Edwynn Houk Gallery, Chicago. Alan G. Artner, *Chicago Tribune*: "If we do not see them as Metzker does, it is owing to a vision that goes to the core. Not the core of experience.... Instead, it is the core of what make a surpassing picture, a picture that isolates and distills what once was invisible, a picture that is keyed up by having been stripped down."

1984
May 2–June 2. *City Whispers* at Laurence Miller Gallery, New York.

November 15–January 1985. *Unknown Territory*, a retrospective, opens at The Museum of Fine Arts, Houston. Tours U.S. Massimo Vignelli designs catalogue.

Bibliography

Exhibitions

1958
Group:
Photographs from the Museum Collection, The Museum of Modern Art, New York (November 26–January 18)

1959
Solo:
My Camera and I in the Loop, The Art Institute of Chicago (December 18–February 21, 1960)

Group:
Photography in the Fine Arts, I, The Metropolitan Museum of Art, New York (catalogue)

Photography at Mid-Century, The George Eastman House, Rochester, New York (catalogue)

1960
Group:
The Sense of Abstraction in Contemporary Photography, The Museum of Modern Art, New York (July–August, catalogue: *Aperture*)

1961
Group:
Seven Contemporary Photographers, The George Eastman House, Rochester, New York (catalogue: *Contemporary Photographer*, traveled)

1962
Group:
Photography, U.S.A., DeCordova Museum, Lincoln, Massachusetts

1963
Group:
Photography 63/An International Exhibition, The New York State Exposition, Syracuse, and The George Eastman House, Rochester, New York (catalogue)

1964
Group:
30 Photographers, State University College at Buffalo, New York

Milwaukee Arts Festival, Wisconsin

1965
Group:
Contemporary Photographs from The George Eastman House Collection, 1900–1964, Rochester, New York (catalogue)

1966
Group:
Contemporary Photography Since 1950, New York State Council on the Arts and The George Eastman House, Rochester, New York (traveled)

American Photography: The Sixties, Sheldon Memorial Art Gallery, University of Nebraska, Lincoln (February 22–March 20, catalogue)

1967
Solo:
The Museum of Modern Art, New York (October 25–January 31, 1968)

Group:
Photography in the Twentieth Century, National Gallery of Canada, Ottawa and The George Eastman House, Rochester, New York (February, traveled, catalogue)

Photography, U.S.A. '67, DeCordova Museum, Lincoln, Massachusetts (catalogue)

The Persistence of Vision, The George Eastman House, Rochester, New York (catalogue)

First National Photography Invitational Exhibition, San Jose State College, California

1968
Group:
Contemporary Photographs, Dickson Art Center, UCLA Art Galleries, Los Angeles (September 23–October 27, catalogue)

Photography and the City (designed by Charles Eames), Smithsonian Institution, Washington, D.C.

Photography as Printmaking, The Museum of Modern Art, New York (catalogue: *Artist's Proof*)

Personal Images by 21 Photographers, W. Ayer, Philadelphia

Focal Point, University of New Hampshire, Durham

Photographer's Gallery, New York (with Paul Caponigro)

1969
Group:
Black and White, A.T. Gallery, New Haven, Connecticut

The Friends of Art Sales and Rental Gallery, Kansas City, Missouri

1970
Solo:
Bennett, Steichen, Metzker: The Wisconsin Heritage in Photography, Milwaukee Art Center (August 1970, catalogue, traveled: University of New Mexico Art Museum, Albuquerque; Wright Art Center, Beloit College, Beloit, Wisconsin)

My Camera and I in the Loop, University of Louisville, Kentucky

Group:
New Photography, USA, organized by The Museum of Modern Art, New York (catalogue; traveled in Japan and Europe, March 1970–April 1972; second version traveled in Latin America, December 1969–May 1972)

12×12, Carr House Gallery, Rhode Island School of Design, Providence (catalogue)

Contemporary Photographers, Peale House Galleries, Pennsylvania Academy of Fine Arts, Philadelphia

Portfolio II, Discovery: Inner and Outer Worlds, The Friends of Photography, Carmel, California

1971
Group:
The Figure and the Landscape, The George Eastman House, Rochester, New York (catalogue)

Variety Show, organized by Western Association of Art Museums (traveled)

1973
Group:
Combattimento per un'Immagine, Fotografi e Pittori, Galerie Civica d'Arte Moderna, Turin, Italy (catalogue)

Landscape / Cityscape. A selection of Twentieth-Century American Photographs, The Metropolitan Museum of Art, New York (November 13, 1973–January 6, 1974)

Art and Photography, Museo Civico de Torino, Turin, Italy

Festival d'Art Contemporain, Paris

Children, Exchange National Bank, Chicago

1974
Solo:
New Mexico, Dayton College of Art, Ohio

New Mexico, The Print Club of Philadelphia

Group:
Visual Interface, Tyler School of Art, Temple University, Philadelphia

Archetype Gallery, New Haven, Connecticut

1975
Group:
For You, Aaron, The Renaissance Society Gallery, University of Chicago (October 6–November 12, brochure)

Bibliotheque Nationale, Paris

The Photographer's Choice, The Addison Gallery of American Art, Phillips Academy, Andover, Massachusetts (book, traveled)

1976
Solo:
The Picture Gallery, Zurich, Switzerland (February)

Group:
Philadelphia, Three Centuries of American Art, Philadelphia Museum of Art (April 11–October 10, catalogue)

Contemporary Trends, The Chicago Photographic Gallery of Columbia College (catalogue)

Contemporary Photographs, Fogg Art Museum, Harvard University, Cambridge, Massachusetts

New Exposures, Museum of Fine Arts, Boston

1977
Group:
The Photographer and the City, Museum of Contemporary Art, Chicago (January 15–March 6, catalogue)

The Extended Frame, Visual Studies Workshop, Rochester, New York (August, checklist, traveled)

Photographs: Sheldon Memorial Art Gallery Collections, University of Nebraska, Lincoln (catalogue)

The Target Collection of American Photography, The Museum of Fine Arts, Houston (February 25–May 1, catalogue, traveled)

Les Expositions Inaugurales, Centre National d'Art et de Culture Georges Pompidou, Paris (catalogue)

Photography: The Selected Image, Pennsylvania State University, University Park, and Edinboro State College, Edinboro, Pennsylvania (traveled)

Locations in Time, International Museum of Photography, The George Eastman House, Rochester, New York

Fresh from Philadelphia, Silver Image Gallery, Ohio State University, Columbus

Time, Philadelphia College of Art

The Drama of Process: Extensions of the Directorial Mode in Photography, Georgia State University, Atlanta

Eye of the West: Camera Vision and Cultural Consensus, Massachusetts Institute of Technology, Cambridge

Photography from the Collection, Part I: American, Philadelphia Museum of Art

1978
Solo:
Pictus Interruptus, Marian Locks Gallery, Philadelphia (April 17–May 9)

Ray K. Metzker: Multiple Concerns, International Center of Photography, New York (September 16–November 5, exhibited in revised form: The Chicago Center for Contemporary Photography; Galerie Delpire, Paris)

Group:
Spaces, Museum of Art, Rhode Island School of Design, Providence (April 11–May 7, catalogue)

Mirrors and Windows: American Photography Since 1960, The Museum of Modern Art, New York (July 28–October 2, traveled: America and Europe, catalogue)

Forty American Photographers, E.B. Crocker Art Gallery, Sacramento, California (February 4–March 5, catalogue)

New Presences in the Fogg Museum, Cambridge, Massachusetts

1979
Solo:
Pictus Interruptus, Light Gallery, New York (March 7–31)

Group:
Contemporary American Photographers: Curator's Choice, Venezia '79: La Fotografia, Venice, Italy (July–September, catalogue)

Intentions and Techniques, Photographs from the Lehigh University Collection, Lehigh University, Bethlehem, Pennsylvania (catalogue)

The Altered Photograph, P.S. 1, Long Island City, New York

Documentary Truth / Photographic Illusion, Bard College, Annandale-on-Hudson, New York

1980
Solo:
Sand Creatures, Pennsylvania Academy of Fine Arts, Philadelphia (January 18–March 2)
Sand Creatures, Light Gallery, New York (January 31–February 23)

Group:
Hazlett Memorial Awards Exhibition, William Penn Memorial Museum, Harrisburg, Pennsylvania (May 1–June 8, catalogue)

The New Vision: Forty Years of Photography at the Institute of Design, Light Gallery, New York (catalogue: *Aperture,* no. 87, traveled)

Aspects of the 70's: Photography, DeCordova Museum, Lincoln, Massachusetts (June 1–August 31, catalogue)

Deconstruction / Reconstruction: The Transformation of Photographic Information into Metaphor, The New Museum, New York (July 12–September 18, catalogue)

Absage an das Einzebild (Renunciation of the Single Image), Fotographische Sammlung, Museum Folkwang, Essen, West Germany (catalogue)

The Imaginary Photo Museum, Photokina, Cologne, West Germany (book)

On the Beach, Vision Gallery, Boston

ICA in Transit, Institute of Contemporary Art, University of Pennsylvania, Philadelphia

1981
Solo:
New Mexico / Pictus Interruptus, Paul Cava Gallery, Philadelphia (February 13–March 14)

Pictus Interruptus, Light Gallery, New York (April 30–May 30)

Group:
Alumni Exhibition, Beloit College, Beloit, Wisconsin

Contemporary Photography by Barbara Crane, Joseph Jachna, Kenneth Josephson, William Larson, and Ray K. Metzker, University of Arkansas, Fayetteville (October, traveled)

Photography: A Sense of Order, Institute of Contemporary Art, University of Pennsylvania, Philadelphia (December 11, 1981–January 27, 1982)

Erweiterte Fotografie / Extended Photography, Association of Visual Artists, Vienna Secession, Austria (October 22–November 22, catalogue)

1982
Solo:
Page and Page Photographic Art, Dallas (April 25, one-day exhibition coinciding with lecture)

Group:
Recent Acquisitions, San Francisco Museum of Modern Art

A History of Photography from Chicago Collections, The Art Institute of Chicago (catalogue)

Target III: In Sequence, Photographic Sequences from The Target Collection of American Photography, The Museum of Fine Arts, Houston (catalogue)

Award-Winning Philadelphia Photographers, Philadelphia Museum of Art (October 1–10)

Ray Metzker / Tom Arndt, Film in the Cities, St. Paul, Minnesota (October 6–27)

Photography of The New Bauhaus, Carlson Gallery, University of Bridgeport, Connecticut (November 20–December 19)

1983
Solo:
City Whispers, Catskill Center of Photography, Woodstock, New York (February 12–March 14)

Memphis State University, Tennessee (February 16–March 1)

City Whispers: Photographs 1980–1982, Marian Locks Gallery, Philadelphia (March 1–26)

Twenty-Five Years, G. H. Dalsheimer Gallery, Baltimore (September 6–October 11)

Ray K. Metzker: Photographs, Multiple Means, Multiple Ends, Carl Solway Gallery, Cincinnati (October 21–November 30)

Edwynn Houk Gallery, Chicago (November 18–December 10)

Group:
20th-Century Photography: Spanning 50 Years of American Art, Jayne H. Baum Gallery, New York (February 3–March 11)

Harry Callahan and His Students: A Study in Influence, Georgia State University Art Gallery, Atlanta (January 5–February 4)

Regional Photographic Educators, Art Institute of Philadelphia (March 14–April 8)

Pertaining to Philadelphia: Sequences, Philadelphia Museum of Art (October 1–31, 1983)

Subjective Vision: The Lucinda W. Bunnen Collection of Photographs, The High Museum of Art, Atlanta (fall, catalogue)

Big Pictures by Contemporary Photographers, The Museum of Modern Art, New York (April 14–June 28, slide set)

Pennsylvania Photographers III, Allentown Art Museum, Pennsylvania (April 24–June 12)

Rencontres International de la Photographie, Arles, France (July 7–September 20)

Photography in America: 1910–Present, Tampa Museum, Florida (September–October)

Past Tensions, Present Tense: Contemporary Photographs from the Miller-Plummer Collection, Mednick Gallery, Philadelphia College of Art (October 1–21)

1984
Solo:
City Whispers, Laurence Miller Gallery, New York (May 2–June 2)

Group:
Cityscapes: 20th Century Urban Images from the Hallmark Photographic Collection, Center for Metropolitan Studies, St. Louis (April 18–May 20, catalogue)

Philadelphia Photography, Jeffrey Fuller Fine Art, Philadelphia (March 17–April 24)

The One and Only: Unique Photographs Since the Daguerreotype, Laurence Miller Gallery, New York (March 28–April 28)

Portfolios
Student Independent 2: Photographic Issue. Chicago: The Art Institute of Chicago, 1957.

Portfolio II, Discovery: Inner and Outer Worlds. Carmel, California: The Friends of Photography, 1970

Providence: Photographic Education Society, Rhode Island School of Design, 1977

Monographs
Edwards, Hugh. *My Camera and I in the Loop: Photographs by Ray Metzker*. Chicago: The Art Institute of Chicago, 1959

Metzker from series *Bennett, Steichen, Metzker: The Wisconsin Heritage in Photography*. Introduction by Tracy Atkinson. Essay by Arnold Gore. Milwaukee: Milwaukee Art Center, 1970.

Ray K. Metzker, *Sand Creatures*. Millerton, New York: Aperture, 1979

Catalogues, Brochures, and Books Other Than Monographs
Photography in the Fine Arts, I. New York: The Metropolitan Museum of Art, 1959.

Photography at Mid-Century. Rochester, New York: The George Eastman House, 1959.

Lyons, Nathan. *Photography 63 / An International Exhibition*. Rochester, New York: The New York State Exposition and The George Eastman House, 1963, pp. 59, 93.

Maddox, Gerald C., ed. *American Photography: The Sixties*. Lincoln, Nebraska: Sheldon Memorial Art Gallery, University of Nebraska, 1966.

Lyons, Nathan. *The Persistence of Vision*. New York: Horizon Press and Rochester, New York: The George Eastman House, 1967, pp. 32–43.

Photography, U.S.A. Lincoln, Massachusetts: DeCordova Museum, 1967.

Lyons, Nathan, ed. *Photography in the Twentieth Century*. New York: Horizon Press and Rochester, New York: The George Eastman House, 1967, pp. xiii, 120.

Heinecken, Robert, ed. *Contemporary Photographs*. Los Angeles: UCLA Art Galleries, 1968.

Ferebee, Ann. *A History of Design from the Victorian Era to the Present*. New York: Nostrand, Reinhold Company, 1970, pp. 115–116.

Life Library of Photography. New York: Time-Life Books. 1970: *The Camera*, p. 44; *Light and Film*, p. 30. 1971: *The Print*, p. 216; *The Art of Photography*, pp. 166, 170–171.

Szarkowski, John. *New Photography, USA*. New York: The Museum of Modern Art, 1970.

Trachtenberg, Alan; Bunnell, Peter C.; and Neill, Peter. *The City: American Experience*. New York: Oxford University Press, 1971, p. 354.

Gassan, Arnold. *A Chronology of Photography*. Athens: Ohio Handbook Co., 1972, p. 198, plates 130–132.

Leonteif, Estelle. *Razerol*. West Burke, Vermont: The Janus Press, 1973 (includes four original electrostatic prints by Metzker).

Szarkowski, John. *Looking at Photographs*. New York: The Museum of Modern Art, 1973, pp. 200–201.

Massar, Phyllis Dearborn. *Landscape / Cityscape: A Selection of Twentieth-Century American Photographs*. New York: The Metropolitan Museum of Art, 1973, pp. 15, 29.

Palazzoli, Daniella, and Carluccio, Luigi, eds. *Combattimento per un'Immagine, Fotografi e Pittori*. Turin, Italy: Galerie Civica d'Arte Moderna, 1973.

Faulkner, Ray, and Ziegfeld, Edwin. *Art Today*. New York: Holt, Rinehart & Winston, Inc., 1974.

Swedlund, Charles. *Photography: A Handbook of History, Materials, and Processes*. New York: Holt, Rinehart & Winston, Inc., 1974, pp. 46–47.

The Museum of Modern Art Calendar. New York: The Museum of Modern Art, 1975.

Craven, George M. *Object and Image: An Introduction to Photography*. Englewood Cliffs, New Jersey: Prentice Hall, Inc., 1975, pp. 192–193.

Wise, Kelly, ed. *The Photographer's Choice: A Book of Portfolios and Critical Opinion*. Danbury, New Hampshire: Addison House, 1975, pp. 66–71, 211, 214.

Snyder, Norman. *The Photography Catalog*. New York: Harper & Row, 1976, p. 218.

Catalog of the UCLA Collection of Contemporary American Photographs. Foreword by Gerald Nordland. Introduction by Robert Heinecken. Los Angeles: Frederick S. Wight Art Gallery, University of California at Los Angeles, 1976, p. 68.

Philadelphia: Three Centuries of American Art. Philadelphia: Philadelphia Museum of Art, 1976, pp. 593–594.

Kaplan, Howard, ed. *Contemporary Trends*. Introduction by Van Deren Coke. Chicago: Chicago Photographic Gallery of Columbia College, 1976, pp. 5–6, 42–45.

Tausk, Peter. *Die Geschichte der Fotografie im 20, Jahrhundert*. Cologne, West Germany: DuMont Buchverlag, 1977, p. 176. Reprinted: *Photography in the 20th Century*, London: Focal Press, 1980, p. 182.

Geske, Norman A., ed. *Photographs: Sheldon Memorial Art Gallery Collections, University of Nebraska-Lincoln*. Lincoln: University of Nebraska Press, 1977, p. 171.

Baker, James, and Lang, Gerald, eds. *Photography: The Selected Image*. University Park, Pennsylvania: Pennsylvania State University, 1977.

Buckland, Gail. *The Photographer and the City*. Chicago: Museum of Contemporary Art, 1977, p. 5 and plate 12.

Tucker, Anne, ed. *The Target Collection of American Photography*. Houston: The Museum of Fine Arts, Houston, 1977, pp. 20, 61.

Simon and Morse. *First Lessons in Black and White Photography*. New York: Holt, Rinehart & Winston, 1978.

Szarkowski, John. *Mirrors and Windows: American Photography Since 1960*. New York: The Museum of Modern Art, 1978, pp. 22, 24, 106–108.

Johnson, Diana L., and Siskind, Aaron. *Spaces*. Providence: Museum of Art, Rhode Island School of Design, 1978, pp. 76–87, 113–116. (Also published as *Bulletin of Rhode Island School of Design, Museum Notes*, vol. 64, no. 4 [April].)

Clisby, Roger D., and Himelfarb, Harvey, eds. *Forty American Photographers*. Sacramento, California: E.B. Crocker Art Gallery, 1978, pp. 9, 49.

Lockwood, Margo. *Bare Elegy*. West Burke, Vermont: The Janus Press, 1979.

Coke, Van Deren. *Photography in New Mexico*. Albuquerque: University of New Mexico, 1979, pp. 40, 142.

Photography Venice '79. Essay by Anne Tucker. New York: Rizzoli International Publications, 1979, pp. 368–369, 380. (Also published as *Photography Venezia '79*. Milan: Electa Editrice, 1979.)

Witkin, Lee D., and London, Barbara. *The Photograph Collector's Guide*. Boston: New York Graphic Society, 1979, pp. 191–192.

Eskildsen, Ute, and Schmalriede, Manfred. *Absage an das Einzelbild (Renunciation of the Single Image)*. Essen, West Germany: Fotographische Sammlung, Museum Folkwang, 1980.

Traub, Charles, ed. *The New Vision: Forty Years of Photography at the Institute of Design*. Essay by John Grimes. Millerton, New York: Aperture, 1982. Also published as *Aperture*, no. 87, pp. 36–37.

Aspects of the 70's: Photography. Essay by James Sheldon. Lincoln, Massachusetts: DeCordova Museum, 1980, p. 17.

Seeley, J. *High Contrast*. Somerville, Massachusetts: Curtin and London, 1980.

Rice, Shelley. *Deconstruction / Reconstruction: The Transformation of Photographic Information into Metaphor*. New York: The New Museum, 1980, pp. 14–16, 40–41.

Gruber, Fritz. *The Imaginary Photo Museum*. Cologne, West Germany: DuMont Buchverlag, 1981, pp. 254, 365.

Campbell, Bryn, ed. *World Photography*. Middlesex, Vermont: The Hamlyn Group, 1981.

Traub, Charles, ed *Light*. New York: Light Gallery, 1981, pp. 60–63, 95.

Kardon, Janet. *Photography: A Sense of Order*. Dialogue between John Gossage and Walter Hopps. Philadelphia: Institute of Contemporary Art, University of Pennsylvania, 1981, pp. 50–51, 54, 56.

Weibel, Peter, and Auer, Anna, eds. *Erweiterte Fotografie Extended Photography*. Vienna, Austria: 5th International Biennial, 1981, pp. 109, 140.

Travis, David. *A History of Photography from Chicago Collections*. Chicago: The Art Institute of Chicago, 1982.

Tucker, Anne, ed. *Target III: In Sequence: Photographic Sequences from The Target Collection of American Photography*. Essay by Leroy Searle. Houston: The Museum of Fine Arts, Houston, 1982, pp. 9, 66, 110–111.

Traub, Charles, ed. *The New Vision: Forty Years of Photography at the Institute of Design*. Millerton, New York: Aperture, 1982, pp. 36–37, 55.

Walsh, George; Naylor, Colin; and Held, Michael. *Contemporary Photographers*. New York: St. Martin's Press, 1982, pp. 508–509.

The Gallery of World Photography. Vol 1: Photography as Fine Art. Tokyo: Shueisha Publications, 1982, title page, p. 196. (Also published as Photography as Fine Art. New York: E. P. Dutton, Inc., 1983, and Toronto and Vancouver: Irwin & Co. Limited, 1983.)

Subjective Vision: The Lucinda W. Bunnen Collection of Photographs. Essay by A.D. Coleman. Atlanta: The High Museum of Art, Atlanta, 1983, pp. 10, 20, 58.

Harry Callahan and His Students: A Study in Influence. Interviews and statements compiled and edited by Louise E. Shaw, Virginia Beahan, and John McWilliams. Essay by Louise E. Shaw. Atlanta: Georgia State University Art Gallery, 1983.

Cohen, Alan, and Vocke, Karla, eds. Photography Interviews: Columbia 1. Dennis Pratt and Leonard Sneider interview with Ray Metzker. Chicago: Columbia College, 1983, pp. 15–18.

Davis, Keith F. Cityscapes: 20th-Century Urban Images from the Hallmark Photographic Collection. Kansas City, Missouri: Hallmark Cards, 1984, p. 5.

Selected Articles, Essays, and Reviews
"Photographs from The Sense of Abstraction." Contemporary Photographer, vol. 1, no. 2 (July / August 1960).

"The Sense of Abstraction in Contemporary Photography." Aperture, vol. 8, no. 2 (1960).

Newhall, Beaumont. "New Talent U.S.A.: Photography." Art in America, vol. 49, no. 1 (1961), p. 56.

"Five Photography Students from the Institute of Design, Illinois Institute of Technology." Aperture, vol. 9, no. 2 (Fall 1961), pp. 75–84.

"Ray K. Metzker." Contemporary Photographer, vol. 2, no. 2 (Fall 1961), pp. 18–21.

Lyons, Nathan. "Photography: The Younger Generation." Art in America, vol. 51, no. 6 (December 1963), pp. 72, 74.

"Portfolio." Aperture, vol. 13, no. 2 (Fall 1967), pp. 2–13.

Dorn, Alva L. "Photo Hobbying: A New Photo Image." Kalamazoo (Michigan) Gazette, November 26, 1967, p. 6.

"Exhibitions." Saturday Review, December 2, 1967, p. 44.

Wasserman, Emily. "Photography." Artforum, vol. 6, no. 5 (January 1968), p. 67.

Camera, vol. 47, no. 5 (May 1968), pp. 24–25, 41.

Zucker, Harvey. "Ray Metzker: Fabulous Multiple Images." Popular Photography, vol. 63, no. 1 (July 1968), pp. 54–55, 93.

White, Minor. Review of The Persistence of Vision. Aperture, vol. 13, no. 4 (1968), pp. 59–60.

Bunnell, Peter C. "Photography as Printmaking." Pratt Graphics Center Artist's Proof, vol. 9, (1969), pp. 24–40.

Portfolio. Camera, vol. 48, no. 11 (November 1969), pp. 40–49.

"12×12." Rhode Island School of Design: Alumni Bulletin, vol. 27, no. 1 (March 1970), pp. 21, 36–37.

"Gallery: Ray K. Metzker's Photocomposition." Life, vol. 68, no. 13 (April 10, 1970), pp. 8–9.

Art & Society (Summer 1971), pp. 5, 31.

"Sequence." Camera, vol. 50, no. 2 (February 1971), pp. 5, 31.

Camera, vol. 54, no. 12 (December 1975), pp. 23, 42 (1 ill.).

Bondi, Ingre, and Misani, Marco. "Ray K. Metzker–An American Photographer and Teacher." Printletter, no. 3 (May–June 1976).

Grundberg, Andy. "Photography: Chicago, Moholy and After." Art in America, vol. 64, no. 5 (September–October 1976), pp. 34–39.

Perloff, Stephen. "Philadelphia: An Explosion of Interest and Activity." Afterimage, vol. 5, nos. 1–2 (May–June 1977), p. 17.

Sieberling, Christopher. "Ray Metzker's Consideration of Light." Exposure, vol. 15, no. 3 (September 1977), pp. 36–39. Reprinted from Bulletin #9 of the University of New Mexico Art Museum, Albuquerque.

Isaacs, Chuck. "Ray K. Metzker: An Interview." Afterimage, vol. 6, no. 4 (November 1978), pp. 12–17.

Kardon, Janet. "Ray K. Metzker at Marian Locks." Art in America, vol. 66, no. 6 (November / December 1978), p. 157.

Lifson, Ben. "Thinking Big by Thinking Small." Village Voice (New York), October 9, 1978, p. 132.

Grundberg, Andy, and Scully, Julia. "Currents: American Photography Today; The Legacy of the German Bauhaus." Modern Photography, vol. 42, no. 11 (November 1978), pp. 116–119, 144, 204, 206, 208.

Squiers, Carol. "Mirrors and Windows: A Nostalgia for the Controllable." The New Art Examiner, vol. 6, no. 3 (December 1978), pp. 6–7.

Edwards, Owen. "Interconnections and Unsuspected Collaborations Are Everywhere." *American Photography*, vol. 1, no. 6 (November 1978), pp. 10–11.

"Review: Ray Metzker; Multiple Concerns." *The Print Collector's Newsletter*, vol. 9, no. 4 (September / October 1978), p. 117.

Pratt, Davis. "Photography in a Teaching Museum." *Apollo*, vol. 107, no. 196 (June 1978), p. 497.

Grundberg, Andy. "Currents: American Photography Today; Mirrors and Windows." *Modern Photography*, vol. 43, no. 1 (January 1979), pp. 114–116, 175, 176, 178, 182.

Bunnell, Peter C. "Ray Metzker." *The Print Collector's Newsletter*, vol. 9, no. 6 (January / February 1979), pp. 177–179.

Perloff, Stephen. "Philadelphia: New Spaces, New Shows and More." *Afterimage*, vol. 6, no. 9 (April 1979), p. 15.

Goldberg, Vicki. "Photography: Ray Metzker." *Cue Reviews* (March 30, 1979).

Artweek, vol. 11, no. 21 (May 31, 1980), p. 14 (1 ill.)

Wise, Kelly. "Sand Creatures." *New England Journal of Photography*, vol. 1, no. 3 (June 1980), p. 14.

Westerbeck, Colin, Jr. "Review: The New Vision." *Artforum*, vol. 9, no. 19 (September 1980), pp. 67–68.

Karmel, Pepe. "Photography Under Moholy's Eye." *Art in America*, vol. 68, no. 41 (October 1980), pp. 39–41.

Marincola, Paula. "Reviews: Obstacle Course." *Afterimage*, vol. 8, no. 10 (May 1981), pp. 17–18.

Grundberg, Andy. "Ray K. Metzker: Form as Expression." *Modern Photography*, vol. 45, no. 11 (November 1981), pp. 122, 131.

Diamonstein, Barbaralee. "Visions and Images: American Photographers on Photography." *Art News*, vol. 80, no. 8 (October 1981), pp. 162–166.

Bunnell, Peter C. "The Current Acceptance of Photography." *afa Newsletter* (October 1981), pp. 2, 6–7.

Solomon-Godeau, Abigail. "Formalism & Its Discontents: Photography: A Sense of Order." *The Print Collector's Newsletter*, vol. 13, no. 2 (May / June 1982), pp. 44–47.

"Ray Metzker / Tom Arndt." *Film in the Cities* (September / October 1982), cover, pp. 1, 5.

Public Collections
Allentown Art Museum, Pennsylvania
Bibliotheque Nationale, Paris
The Art Institute of Chicago
The Art Museum, Princeton University, New Jersey
Australian National Gallery, Canberra, New South Wales
Baltimore Museum of Art
Center for Creative Photography, University of Arizona, Tucson
Davidson Art Center, Wesleyan University, Middleton, Connecticut
The Detroit Institute of Arts
E.B. Crocker Art Gallery, Sacramento, California
Exchange National Bank of Chicago
Fogg Art Museum, Harvard University, Cambridge, Massachusetts
Free Library of Philadelphia
Grunwald Center for the Graphic Arts, University of California
at Los Angeles
The High Museum of Art, Atlanta
International Museum of Photography, The George Eastman House,
Rochester, New York
The J.B. Speed Art Museum, Louisville, Kentucky
Krannert Art Museum, University of Illinois, Champaign
The Metropolitan Museum of Art, New York
Milwaukee Art Museum, Wisconsin
Museum of Art, Rhode Island School of Design, Providence
Museum of Fine Arts, Boston
The Museum of Fine Arts, Houston
Museum of Fine Arts, St. Petersburg, Florida
The Museum of Modern Art, New York
National Gallery of Canada, Ottawa
National Museum of American History, Smithsonian Institution,
Washington, D.C.
National Museum of American Art, Smithsonian Institution,
Washington, D.C.
Philadelphia Museum of Art
The Picker Art Gallery, Colgate University, Hamilton, New York
San Antonio Museum Association
San Francisco Museum of Modern Art
Sheldon Memorial Art Gallery, University of Nebraska, Lincoln
The St. Louis Art Museum, Missouri
The Toledo Museum of Art, Ohio
University Art Museum, The University of New Mexico, Albuquerque
Virginia Museum of Fine Arts, Richmond
Worcester Art Museum, Massachusetts

Gartside, Thomas. "Philadelphia's Heirs to Moholy-Nagy Reject 'Formalist Tag.'" *New Art Examiner*, vol. 10, no. 2 (December 1982), pp. 10–11.

Bultman, Janis. "A Formalist with Heart: An Interview with Ray K. Metzker." *Darkroom*, vol. 4, no. 8 (December 1982), pp. 34–39, 47.

Davis, Douglas. "Joys of the Multiple Image." *Newsweek* (August 16, 1982), pp. 62–63.

Cook, Jno. "Photography: The Chicago School." *Nit & Wit, Chicago's Arts Magazine* (January / February 1983), pp. 30–31.

Donohoe, Victoria. "Poignancy Colors His Photographs." *Philadelphia Inquirer*, March 4, 1983, p. 34.

"Big Pictures by Contemporary Photographers." *MOMA: The Museum of Modern Art*, no. 26 (Spring 1983), pp. 1–2.

"Photographers and Professionals III." *The Print Collector's Newsletter*, vol. 14, no. 3 (July / August 1983), p. 88.

Dorsey, John. "Photographer Metzker Places Aesthetics Before Subject." *The Sun* (Baltimore), September 12, 1983.

Young, Barbara. "Happiness Is Metzker Photographs." *Morning Sun* (Baltimore), October 8, 1983.

Artner, Alan G. "Metzker Eclipses Many Photographic Styles by Using Slivers of Light and Dark." *Chicago Tribune*, November 25, 1983, Sec. 5, p. 18.

Thornton, Gene. "Critics' Choices: Photography." *The New York Times*, May 13, 1984.

Acknowledgments

Anne Wilkes Tucker
Gus and Lyndall Wortham Curator

Support for this project began three years ago with research grants from Gay Block, Mr. and Mrs. Toby Miller, Laurence Miller Gallery, Dr. and Mrs. Robert C. Page, and Mrs. Fay Horton Sawyier. Subsequent support for the exhibition and catalogue was received from the National Endowment for the Arts, Alice Pratt Brown, The McAshan Educational and Charitable Trust, The Jesse H. and Mary Gibbs Jones Exhibition Endowment Fund, Transco Energy Company, and Peat, Marwick, Mitchell & Co. While writing the catalogue, I was a John Simon Guggenheim Memorial Foundation Fellow. I would also like to acknowledge the hospitality of Ray K. Metzker; Martha Chahroudi, Alice Ballard, and Josh Mittendorf at Far Country, Philadelphia; Houston Center for Photography; and Jim and Pauline Van Bravel Kearney for use of the 88 Ranch while preparing the exhibition and catalogue. Ray K. Metzker acknowledges the fellowships he received from the John Simon Guggenheim Memorial Foundation and the National Endowment for the Arts.

Respect and gratitude are offered to Ray K. Metzker for his patience, his steady commitment to excellence, the generosity of his time, and his unfailing support.

For sharing research and personal insights about Ray Metzker and his work, appreciation is due Alan Cohen, Van Deren Coke, Helen Drutt, Martus Granirer, Nathan Lyons, John Szarkowski, and Laurence Miller. The bibliography was prepared by Kathy Reiser, building on work prepared by Anne Bushman and Margaret Moore for the catalogue *Target III: In Sequence*.

Special thanks to Massimo Vignelli and his assistant, Sukey Bryan, for catalogue design; Carole Kismaric, David Crossley, and Mary Wachs for editing; Leah Hoffmitz for production of mechanicals; Gary McKinnis for reproduction prints; Charles Gershwin for production supervision; and Alison Bond, literary agent.

The catalogue and its accompanying exhibition have been made possible through the generosity of the Trustees of The Museum of Fine Arts, Houston. The exhibition would have been impossible without the support of Director Peter C. Marzio and the staff of the museum, in particular: David B. Warren, William G. Bradshaw, Margaret Skidmore, Edward B. Mayo, Charles Carroll, Jack Eby, Maggie Olvey, John Halaka, Lainie Gordon, and most especially, Elaine Mills.

Personal thanks to Joe D. Wheeler.

Lenders to the exhibition are The Art Institute of Chicago; Laurence Bach and Penny Balkin Bach; Don Camera; Paul Cava; Allan Chasanoff; Alan Cohen; Kathleen MacHan Conant and David S. Conant; Mr. and Mrs. William Daley; G.H. Dalsheimer Gallery; Davison Art Center, Wesleyan University; Margo Dolan; The Exchange National Bank of Chicago; Carol Fertig; Elizabeth S. Glassman; Tom Goodman; Martus Granirer; Malcolm and Clarice Grear; The High Museum of Art, Atlanta; Mr. and Mrs. Bertram Horowitz; International Museum of Photography, The George Eastman House; Krannert Art Museum, University of Illinois, Champaign; Dirk Lohan; Mr. and Mrs. S.M. McAshan, Jr.; Gary McKinnis; The Metropolitan Museum of Art; The Miller–Plummer Collection of Photography; Laurence Miller and Lorraine Koziatek; Ray K.

Metzker and Laurence Miller Gallery; Lilyan and Toby Miller; Milwaukee Art
Center; The Museum of Fine Arts, Houston; The Museum of Modern Art; Dr.
and Mrs. Perry W. Nadig; Paul Monte Narkiewicz; Dr. and Mrs. Robert C.
Page; Dr. William Pieper; Martha Heineman Pieper; Philadelphia Museum
of Art; Museum of Art, Rhode Island School of Design; Ann Rothschild;
National Museum of American History, Smithsonian Institution; National
Museum of American Art, Smithsonian Institution; Miriam Mednick Rothman
and Milton A. Rothman; San Antonio Museum Association; San Francisco
Museum of Modern Art; The J.B. Speed Art Museum; Joseph E. Seagram &
Sons, Inc.; The Toledo Museum of Art; Grunwald Center for the Graphic Arts,
University of California at Los Angeles; University Art Museum, University
of New Mexico; Claire Van Vliet; Wallace S. Wilson; Delia Wishnew; and
Worcester Art Museum.

I would especially like to thank the following lenders for permission to
reproduce unique works: *Composites: Philadelphia*, 1967, and *Composites:
Philadelphia*, 1964, in the collection of the Philadelphia Museum of Art;
Composites: Philadelphia, 1965, and *Whimsey*, No. 4, 1974, in the collection of
Ray K. Metzker; *Composites: Philadelphia*, 1966, in the collection of the Laurence
Miller Gallery; and *Composites: Spruce Street Boogie*, 1966 / 1981, in The Target
Collection of American Photography, The Museum of Fine Arts, Houston.